THE ART
COMIC BOOK
DRAWING

More than 100 drawing and illustration techniques for rendering comic book characters and storyboards

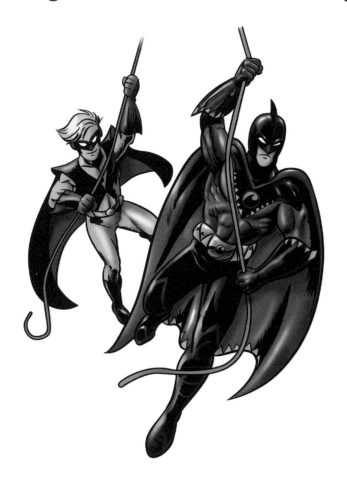

MAURY AASENG
BOB BERRY
JIM CAMPBELL
DANA MUISE
JOE OESTERLE

Walter Foster

Brimming with creative inspiration, how-to projects, and useful information to enrich your everyday life, Quarto Knows is a favorite destination for those pursuing their interests and passions. Visit our site and dig deeper with our books into your area of interest: Quarto Creates, Quarto Cooks, Quarto Homes, Quarto Lives, Quarto Drives, Quarto Explores, Quarto Gifts, or Quarto Kids.

First published in 2020 by Walter Foster Publishing, an imprint of The Quarto Group. 26391 Crown Valley Parkway, Suite 220, Mission Viejo, CA 92691, USA.
T (949) 380-7510 F (949) 380-7575 www.QuartoKnows.com

Walter Foster Publishing titles are also available at discount for retail, wholesale, promotional, and bulk purchase. For details, contact the Special Sales Manager by email at specialsales@quarto.com or by mail at The Quarto Group, Attn: Special Sales Manager, 100 Cummings Center, Suite 265D, Beverly, MA 01915, USA.

ISBN: 978-1-63322-830-6

Digital edition published in 2020
eISBN: 978-1-63322-831-3

Printed in China
10 9 8 7 6 5 4 3 2

Contents

Introduction 4

Tools & Materials 6

Digital Illustration 9

Drawing Basics 10

Inking Techniques 12

Creating Characters 16

Heads & Bodies 16

Features 22

Hands & Feet 26

Bodies in Motion 30

Villains 38

Character Designs 42

Battles 46

Building Comic Characters 52

Bionic Hero 56

The Red Wraith 62

Evil Genius 68

Ninja Warrior74

Megaguy 80

Ms. Mega 84

Thorn 92

The Bulk 98

Lady Electric 102

The Shark & The Tadpole 106

Adding Speech 112

Speech Balloons & Captions113

Some Dos & Don'ts 117

Sound Effects118

Creating a Story Segment120

About the Artists 128

Introduction

"Comics" are a hybrid genre in which illustrations and written words work together to tell a story. While a children's storybook technically has a similar definition, comics are a very special and unique art form. Each page is filled with action, with "frame-by-frame" drawings each playing their part to keep the narrative going as you follow along.

While it is a relatively new art form, today it exists with enormous representation and variety and serves as the occupation of tons of creative individuals. It even inspires other art forms, such as TV, film, and animation. With the advancement of technology, comics have also transcended beyond their origins in black-and-white newspaper prints to full-color graphic novels and digital formats, such as webcomics.

As the art of comics has gained popularity over the years, different countries have developed their own styles and titles, many of which have become internationally recognized. Heroes such as "Batman" and "The X-Men" are international hits, drawn by artists from all over the world. In Japan, mangaka, such as Osamu Tezuka, take the comic art form in its own amazing direction. France, the United Kingdom, and Korea also make up a small handful of many countries that have made monumental contributions to this art genre.

As you delve into this creative world with the help of this book, it is our hope that you will glean a deeper understanding and respect for the art form and eventually even create your own work. The lessons and projects in this book will help you build a strong foundation from the ground up: learning how to create a story; finding inspiration; and, most importantly, creating the characters that will make your story come to life for you and your audience.

Learning how to draw and, specifically, how to make your own comic, will take patience, practice, and time. Remember that everyone starts at the beginning—even the best of us—so don't lose motivation!

Use a pencil to practice your comic book drawing skills on the interactive pages, or scan and print on thicker paper to create finished works of art with colored pencils, markers, or ink. The choice is up to you!

Tools & Materials

Comic book art can be created using a variety of tools and materials. Most of the artwork in this book was colored on a computer, but don't worry if you're not set up for that. You can use plenty of traditional media such as pencils, inks, colored pencils, markers, and paint. Below are the supplies you'll need to get started.

PAPER

Sketch pads and inexpensive printer paper are great for sketching and working out your ideas. Tracing paper can be useful for creating a clean version of a sketch using a light box. Cardstock is sturdier than thinner printer paper, which makes it ideal for drawing repeatedly or for heavy-duty artwork. You may also want to have illustration board on hand.

PENCILS

Pencil lead, or graphite, varies in darkness and hardness. Pencils with a number and an H have harder graphite, which marks paper more lightly. Pencils with a number and B have softer graphite, which makes darker marks. A good pencil for sketching is an H or HB, but you can also use a regular No. 2 pencil.

COLORED PENCILS

Colored pencils layer over each other easily. They come in wax-based, oil-based, and water-soluble versions. Oil-based pencils complement wax-based pencils nicely. Water-soluble pencils react to water in a manner similar to watercolor. In addition to creating finished art, colored pencils are useful for enhancing small details.

ERASERS

Vinyl and kneaded erasers are both good to have on hand. A vinyl eraser is white and rubbery and is gentler on paper than a pink eraser. A kneaded eraser is like putty. It can be molded into shapes to erase small areas. You can also use it to lift graphite off paper to lighten artwork.

PAINT

Have fun exploring acrylic, watercolor, and even gouache paint. Watercolor paints are available in cakes, pans, and tubes. Tube paints are fresher and the colors are brighter. Acrylic paint dries quickly, so keep a spray bottle of water close to help keep the paint on your palette fresh. It's a good idea to have two jars of water when you paint: one for diluting your paints and one for rinsing your brushes.

ART MARKERS

Alcohol-based art markers are perfect for adding bold, vibrant color to your artwork. They are great for shading and laying down large areas of color. Markers and colored pencils can be used in combination with paint to enhance and accent your drawings.

LIGHT BOX

A light box is a useful and generally inexpensive tool with a transparent top and a light inside. The light illuminates paper placed on top, allowing lines to show through for easy tracing. Simply tape your rough drawing on the surface of the light box, place a clean sheet of paper on top of your sketch, and turn the light on.

QUILL OR DIP PEN

Quill and dip pens provide some flexibility with line when inking. You can purchase different sizes of nibs. Be careful when inking with these tools. They often leave lines that stay wet for several minutes. Make sure you allow for plenty of drying time!

INDIA INK

India ink is black ink made of carbon. It has been used in various forms since ancient times and became standard for writing and printing in the Western world around the turn of the 20th century. India ink is a traditional inking material for comic book artists, but you do not have to use it to ink your art.

INKING BRUSH

Inking with a brush can create smoother, livelier lines and is great for creating thick-to-thin strokes. Working with a brush takes more time and requires a lot of practice to become proficient. Look for a sable brush with a sharp point. When inking with a brush, dip it in water first and roll the excess water onto a paper towel. Then dip it in ink.

TEMPLATES & CURVES

You can find circle, ellipse, and curve templates at any art supply store. These templates are perfect for making dialogue balloons. It's also helpful to have a flexible drawing curve, which you can bend to match curved lines in your sketches. You can use this helpful tool to create a thick-and-thin line quality by stroking your line several times and adjusting the position of the curve to build a line that is thicker in the middle and thinner at the ends.

Digital Illustration

Unlike drawing or painting, digital illustration allows you to make dramatic enhancements with just a few clicks of a mouse. It helps to have an understanding of the basic tools and functions of image-editing software. Here are some basic Photoshop® functions you'll find helpful.

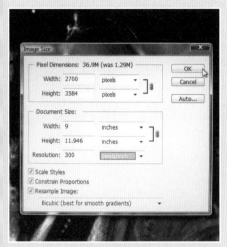

IMAGE RESOLUTION

When scanning your drawing or painting into Photoshop, it's important to scan it at 300 dpi (dots per inch) and 100% the size of the original. A higher dpi carries more pixel information and determines the quality at which your image will print. However, if you intend for the image to be a piece of digital art only, you can set the dpi as low as 72. View the dpi and size under the menu Image > Image Size.

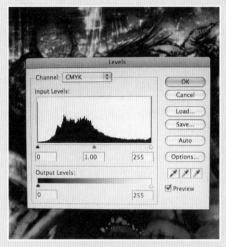

LEVELS

With this tool (under Image > Adjustments), you can change the brightness, contrast, and range of values within an image. The black, midtone, and white of the image are represented by the three markers along the bottom of the graph. Moving the black marker right will darken the overall image, moving the white marker left will lighten the overall image, and sliding the midtone marker left or right will make the midtones darker or lighter respectively.

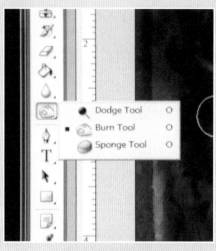

DODGE & BURN TOOLS

The dodge and burn tools, photography terms borrowed from the old dark room, are also found on the basic tool bar. Dodge is synonymous with lighten; burn is synonymous with darken. On the settings bar under "Range" you can select highlights, midtones, or shadows. Select which of the three you'd like to dodge or burn, and the tool will only affect these areas.

ERASER TOOL

The eraser tool is found in the basic tool bar. When working on a background layer, the tool removes pixels to reveal a white background. You can adjust the diameter and opacity of the brush to control the width and strength of the eraser.

PAINTBRUSH TOOL

The paintbrush tool allows you to apply layers of color to your canvas. Like the eraser, dodge, and burn tools, you can adjust the diameter and opacity of the brush to control the width and strength of your strokes.

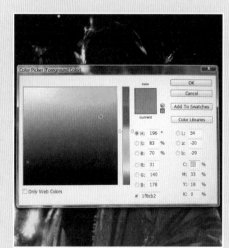

COLOR PICKER

Choose the color of your "paint" in the Color Picker window. Select your hue by clicking within the vertical color bar; then move the circular cursor around the box to change the color's tone.

Drawing Basics

MOVING FROM SHAPE TO FORM

The four basic shapes—the circle, rectangle, triangle, and square—can appear to be three-dimensional by adding a few carefully placed lines that suggest additional planes. By adding ellipses to the circle, rectangle, and triangle, you give the shapes dimension and begin to produce a form within space. The shapes become a sphere, a cylinder, and a cone. Add a second square above and to the side of the first square, connect them with parallel lines, and you create a cube.

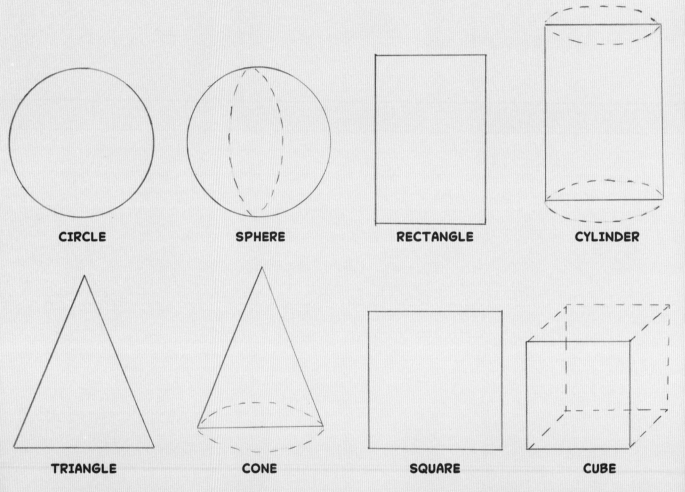

CIRCLE SPHERE RECTANGLE CYLINDER

TRIANGLE CONE SQUARE CUBE

ADDING VALUE TO CREATE FORM

A shape can be further defined by showing how light hits the object to create highlights and shadows. First note from which direction the source of light is coming. In this example, the light source is beaming from the upper right. Then add the shadows accordingly. The *core shadow* is the darkest area on the object and is opposite the light source. The *cast shadow* is what is thrown onto a nearby surface by the object. The *highlight* is the lightest area on the object, where the reflection of light is strongest. *Reflected light*, often overlooked by beginners, is surrounding light that is reflected into the shadowed area of an object.

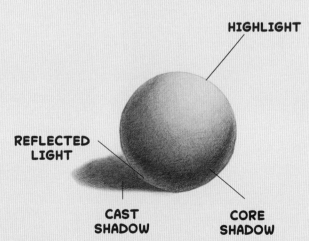

HIGHLIGHT

REFLECTED LIGHT

CAST SHADOW

CORE SHADOW

CREATING VALUE SCALES

Artists use scales to measure changes in value. Value scales also serve as a guide for transitioning from lighter to darker shades. Making your own value scale will help familiarize you with the different variations in value. Work from light to dark, adding more and more tone for successively darker values (as shown below left). Then create a blended value scale by using a blending stump to blend each value into its neighboring value to create a gradation (as shown below right).

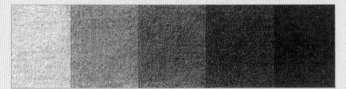

BASIC TECHNIQUES

The basic pencil techniques below can help you learn to render everything from people to machines. Whatever techniques you choose, remember to shade evenly in a back-and-forth motion over the same area, varying the spot where the pencil point changes direction.

HATCHING
This technique consists of a series of parallel strokes. The closer the strokes, the darker the tone will be.

CROSSHATCHING
For darker shading, layer parallel strokes on top of one another at varying angles.

GRADATING
To create gradated values, apply heavy pressure with the side of your pencil, gradually lightening as you go.

SHADING DARKLY
Apply heavy pressure to the pencil to create dark, linear areas of shading.

SHADING WITH TEXTURE
For a mottled texture, use the side of the pencil tip to apply small, uneven strokes.

BLENDING
To smooth out the transitions between strokes, gently rub the lines with a blending tool or your finger.

Inking Techniques

Master these basic inking techniques, and you'll be off to a great start! Once you have these traditional techniques down, try experimenting with different media and line-making. You can achieve a variety of looks with just a few tools and techniques.

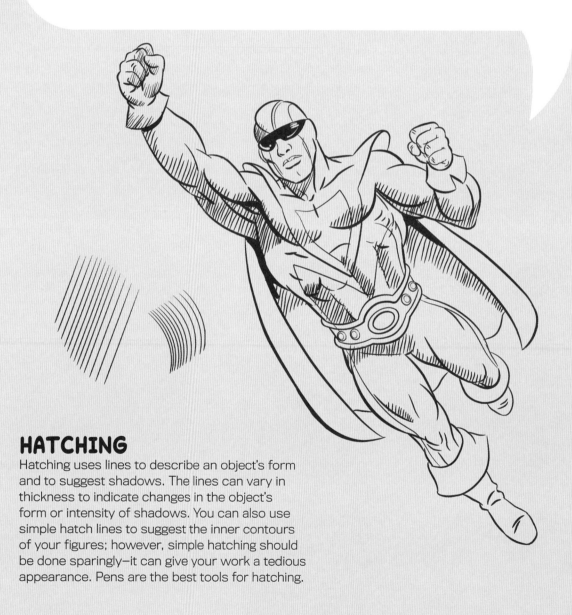

HATCHING

Hatching uses lines to describe an object's form and to suggest shadows. The lines can vary in thickness to indicate changes in the object's form or intensity of shadows. You can also use simple hatch lines to suggest the inner contours of your figures; however, simple hatching should be done sparingly—it can give your work a tedious appearance. Pens are the best tools for hatching.

CROSSHATCHING

Introduce hatch lines at different angles to build up shadowing or show changes in surfaces. Try to avoid crosshatching at right angles, which can create a dull grid that may detract from your drawing. Crosshatching is a good way to graphically represent gradual changes in tone or shadow.

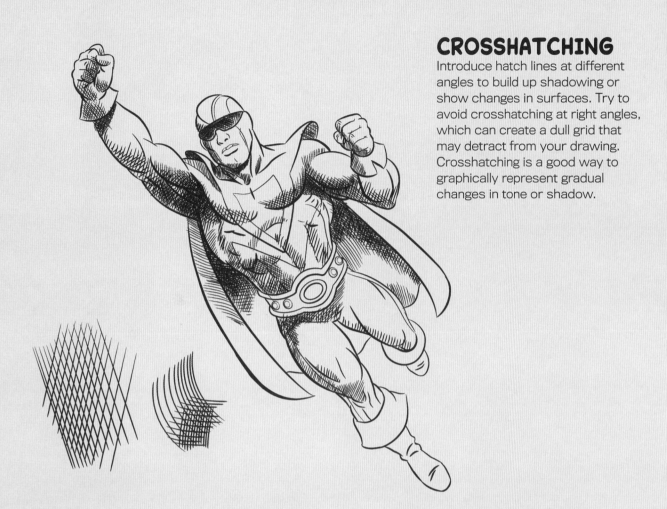

FEATHERING

Generally done with a brush or quill pen, feathering is the iconic comic inking style used by most inkers. There are two distinct strokes: the thick-to-thin stroke and the thin-thick-thin stroke. Both require controlling the pressure you apply when drawing the line. Whether you use a pen or a brush, the greater the pressure you apply as you draw, the thicker the line. Feathering can also be an effective way to render outlines or suggest shadow.

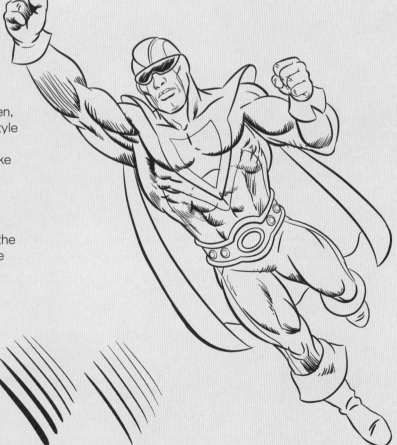

CONTEMPORARY TECHNIQUES

Many contemporary inkers and artists choose less traditional inking methods. Because they require less skill and drying time, many artists prefer various fine and medium marker pens. Some marker pens can respond to changes in pressure to create thick-to-thin "feathered" strokes.

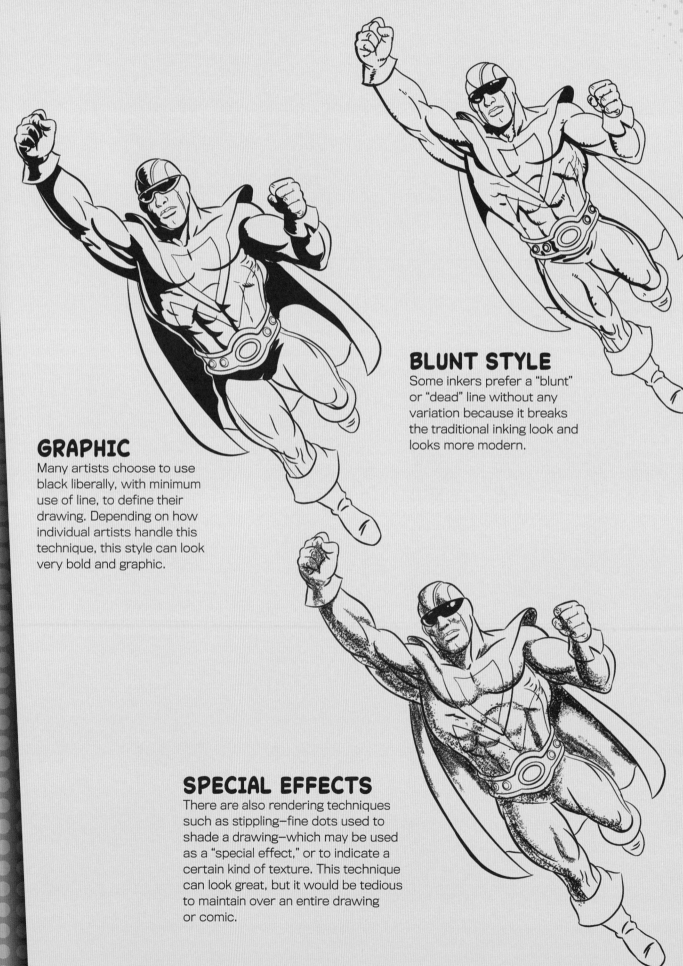

BLUNT STYLE

Some inkers prefer a "blunt" or "dead" line without any variation because it breaks the traditional inking look and looks more modern.

GRAPHIC

Many artists choose to use black liberally, with minimum use of line, to define their drawing. Depending on how individual artists handle this technique, this style can look very bold and graphic.

SPECIAL EFFECTS

There are also rendering techniques such as stippling—fine dots used to shade a drawing—which may be used as a "special effect," or to indicate a certain kind of texture. This technique can look great, but it would be tedious to maintain over an entire drawing or comic.

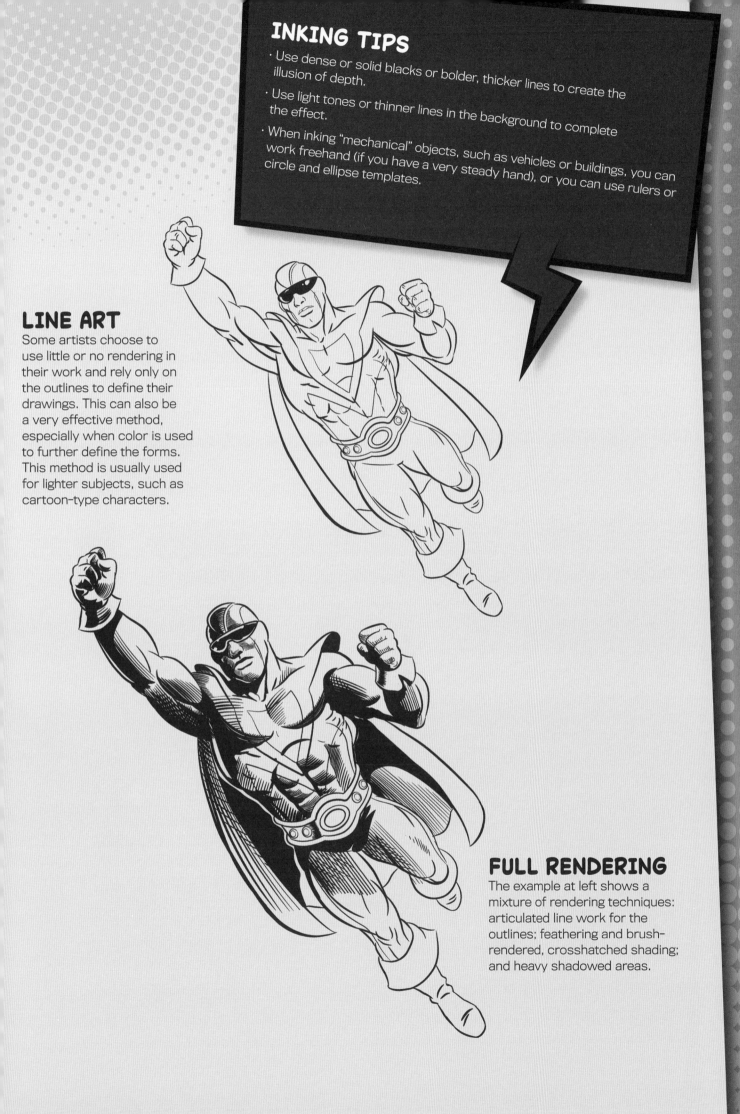

INKING TIPS

· Use dense or solid blacks or bolder, thicker lines to create the illusion of depth.

· Use light tones or thinner lines in the background to complete the effect.

· When inking "mechanical" objects, such as vehicles or buildings, you can work freehand (if you have a very steady hand), or you can use rulers or circle and ellipse templates.

LINE ART

Some artists choose to use little or no rendering in their work and rely only on the outlines to define their drawings. This can also be a very effective method, especially when color is used to further define the forms. This method is usually used for lighter subjects, such as cartoon-type characters.

FULL RENDERING

The example at left shows a mixture of rendering techniques: articulated line work for the outlines; feathering and brush-rendered, crosshatched shading; and heavy shadowed areas.

15

Creating Characters

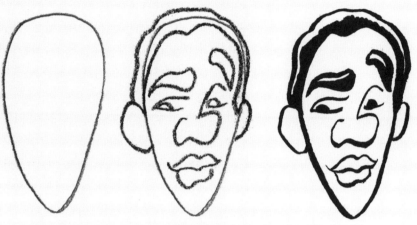

A carrot shape sets the stage for a strong-jawed, confident man, suggesting that a tall, lean body accompanies the character's face.

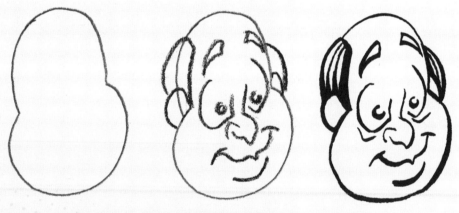

A pear shape and some jolly features give this fellow the look of a happy butler.

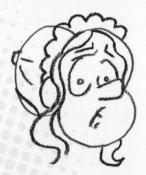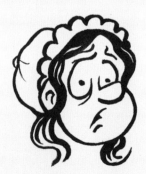

With this strange popcorn-like shape, one bump becomes the cheek, another bump becomes the forehead, and the third bump becomes the bonnet of this housemaid.

Much of a character's personality and attitude can be captured with the initial simple shape. For instance, a shape with sharp angles can suggest an angry or intense person; wide, round shapes can suggest a comfortably idle character; and a strange shape often suggests an awkward character. Try as many different shapes as you can—you may be surprised at the variety of characters that live in your head!

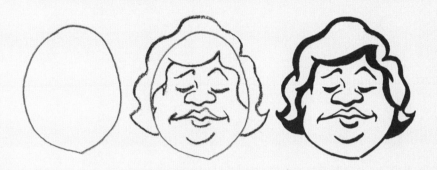

A proud woman can emerge out of a wide oval with a pointed bottom tip. Her closed eyes and lips and a maintained hairstyle reflect a woman with a no-nonsense attitude!

An elongated trapezoid provides the shape of an exhausted and yawning man. An asymmetrical shape for his mouth and vertically stretched eyes suggest the bizarre look of a face when captured mid-yawn!

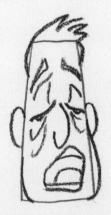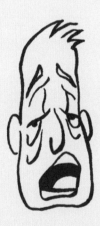

A skinny, hooked teardrop shape becomes a bitter wizard with a twisted beard, a bald head, and a hooked nose.

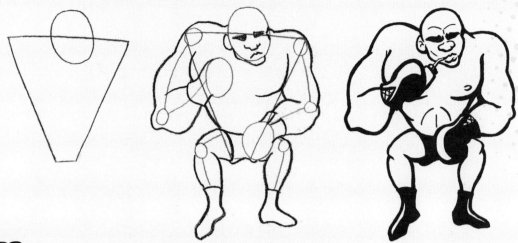

BOXER

A circle and an inverted trapezoid create the powerful body of an intimidating boxer. To create his limbs, draw lines with circles marking the joints before adding the beefy flesh surrounding them. Add some tough-guy features, such as a lumpy nose and eyebrows so dark and thick they hide his eyes.

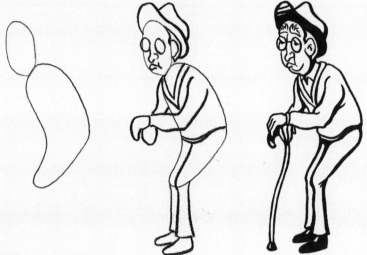

ELDERLY MAN

A boomerang shape creates the sloping back of this hunched man. Use a simple, elongated oval for the head and then sketch in his limbs, hat, and facial features. After adding bushy eyebrows, thick glasses, and a rubber-tipped cane, this guy's ready to hit the bingo hall!

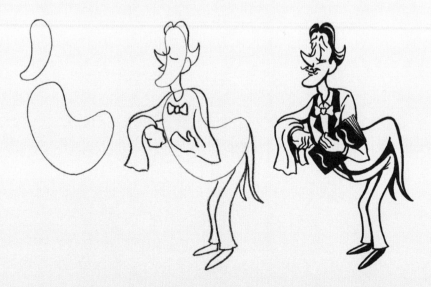

WAITER

Start with two abstract, curved shapes floating near each other (one marking the head, the other the body). After connecting the shapes with a noodlelike neck, accompanied by noodlelike legs and arms, the waiter character begins to take shape. His appearance is heightened by his exaggerated posture, silly tuxedo, and the swoop of hair and tiny mustache.

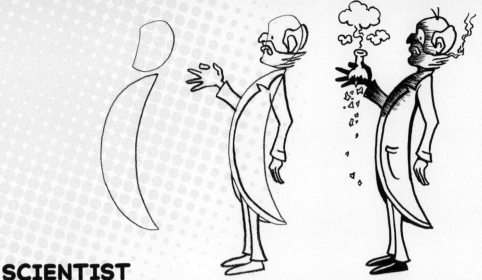

SCIENTIST

A banana shape for the body is perfect for this absent-minded scientist. The inward-sloping back suggests movement and surprise. Draw an oval with one flat side for the head and add arms, legs, hands, and facial features, including a beard. All that's left to add is the broken vial, some smoke, and dark hatch lines to illustrate how this genius "got burned" by an experiment gone wrong.

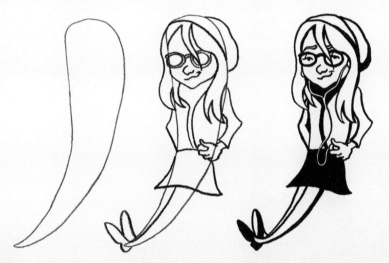

HIPSTER

A chili pepper shape captures the posture of this young hipster. Add an arm off to one side, and the tip of the chili becomes indistinct legs leaning on a wall. The top morphs into a girl's head wearing a floppy hat, dark-framed glasses, earbuds, and a smug expression. If only her parents understood her.

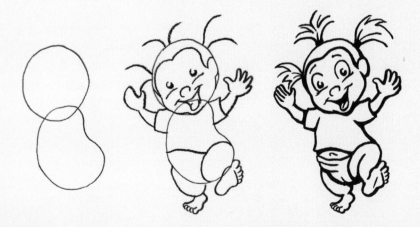

TODDLER

A lima bean with a large circle on top creates the framework for a rambunctious toddler. Stubby legs, outstretched hands, and the face at a tilted angle creates the look of a tiny kid dashing toward something (or someone) exciting. Three fountainlike ponytails, an exposed belly button, and a visible tongue help create the young toddler's expression of uninhibited enthusiasm.

IT'S YOUR TURN!

Practice turning the shapes and forms below into personalized heads and bodies.

Want to know the best thing about being a cartoonist? You're never wrong! Mathematicians can be wrong, scientists can be wrong, and we all know that the people who cut your hair can be wrong. Because you're creating a character the way you see it in your head, it's never wrong.

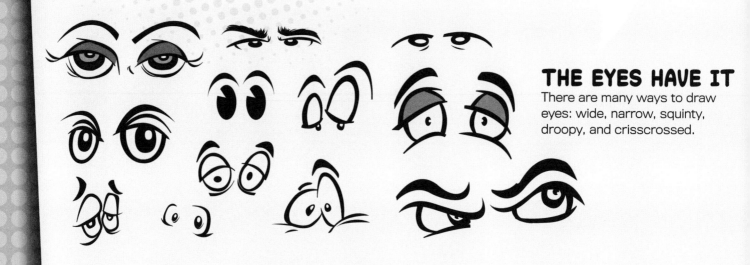

THE EYES HAVE IT
There are many ways to draw eyes: wide, narrow, squinty, droopy, and crisscrossed.

THE NOSE KNOWS
On its own, the nose doesn't necessarily convey emotions, but it does crinkle when it smells something bad, elongates slightly when in shock or surprise, and flares the nostrils in anger or determination.

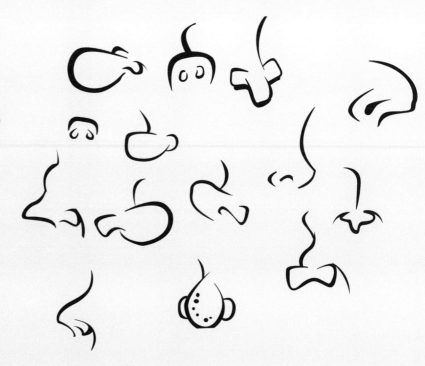

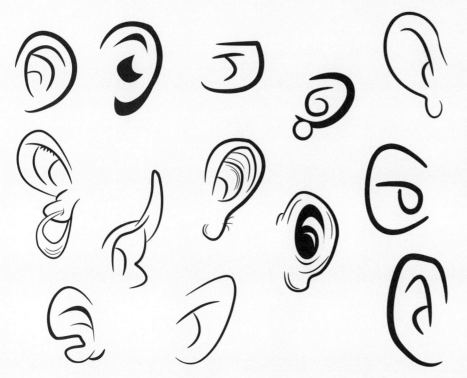

I HEAR YOU

Ears can be C-shaped or V-shaped. Some might wear earrings. And how can people hold up their glasses if not for specially designed ears?

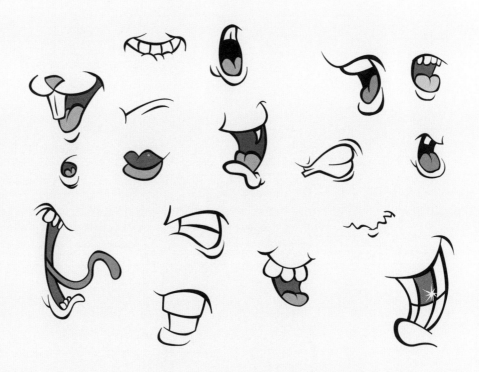

MOUTHING OFF

Perhaps the most important facial feature when trying to convey emotion is the mouth. The mouth has more working parts than the eyes or nose, giving the cartoonist more elements to play with and exaggerate.

IT'S YOUR TURN!

On these pages, draw a variety of features to convey different emotions.

OK, show of hands. Everybody who hates drawing hands raise your right hand. Now everybody who really, really hates drawing hands raise your left hand. Allow me to share a little cartooning secret with you: Nobody likes drawing hands. Drawing hands is like eating broccoli or multiplying fractions. You don't want to do it, but it's good for you. There are numerous books and tutorials on the Internet to teach you the rules of drawing realistic hands. But who cares? We're cartoonists. We don't need no stinkin' rules.

Sure, if you want, you can draw realistic-looking hands...

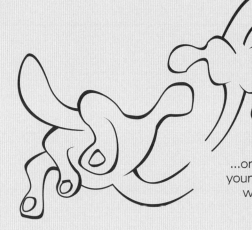

...or you can make your hands look like wet noodles...

...or bendable sausages.

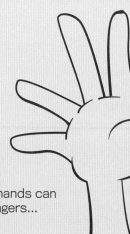

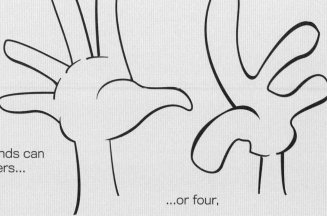

In cartooning, hands can have five fingers...

...or four,

HANDS CAN BE A COMPELLING AND PERSUASIVE WAY TO CONVEY EMOTION AND EXPRESSION.

but there's no reason a character can't have as many or as few fingers as you'd like.

Feet can be even more fun to draw than hands because no one expects any emotion or personality from them.

The just-off-work foot

The "kick back" cowboy

A ballerina—or aspiring ninja

A pirate or caveman

Sometimes four toes are better than five

Nothing scratches the bottom of your own foot like your other foot

These feet are about to dip themselves in the ol' waterin' hole

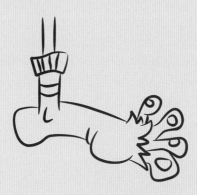

Holes in socks can say, "I need a job" or "I'm too lazy to buy new ones."

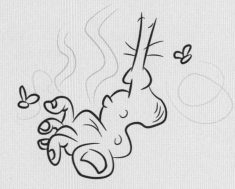

And of course, the stink foot

IT'S YOUR TURN!

Try drawing hands to gesture and communicate.

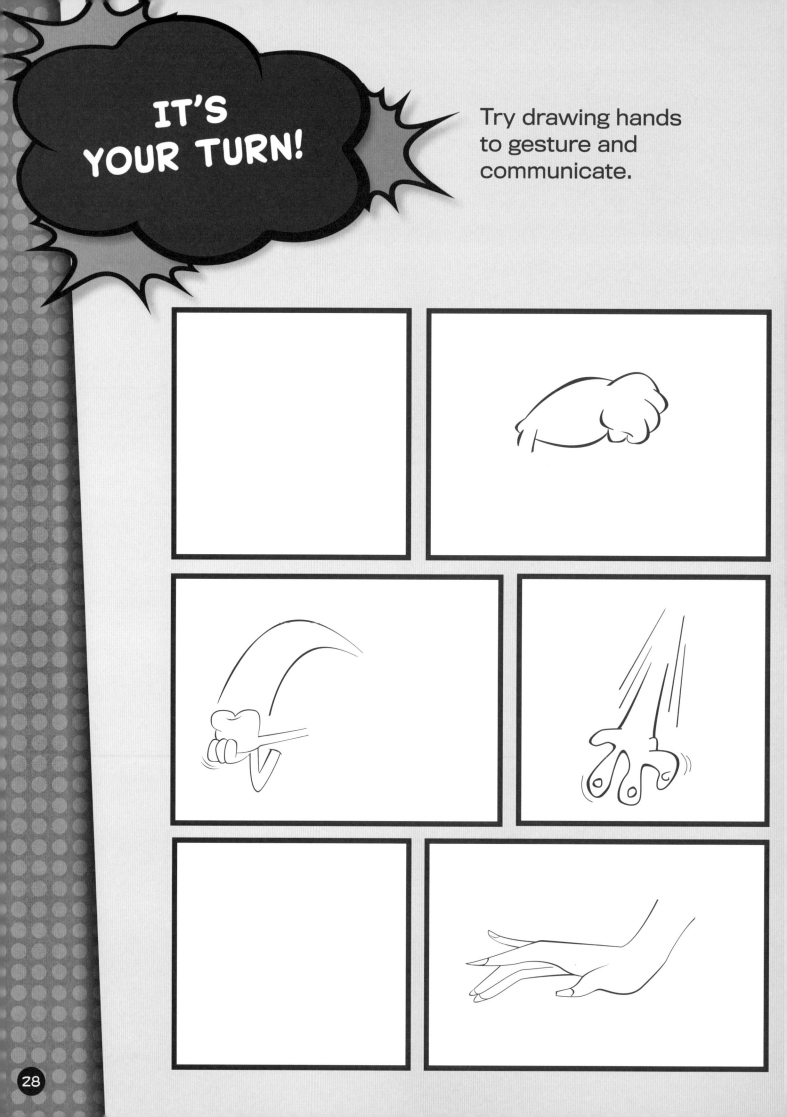

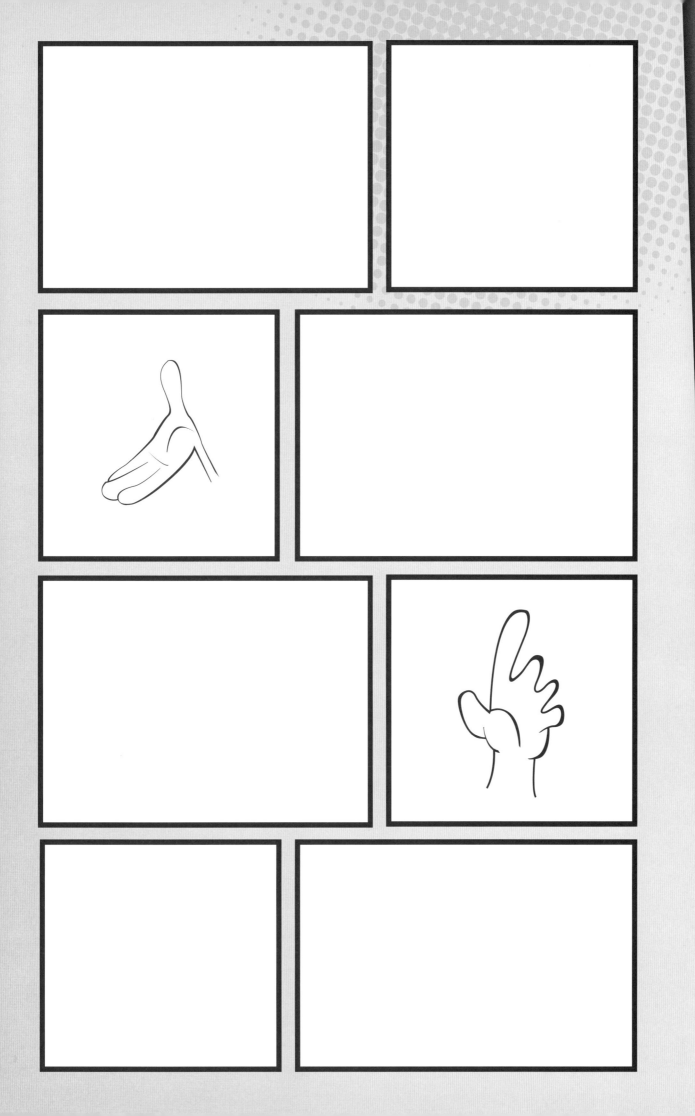

Bodies in Motion

SIMPLE STANDING POSE

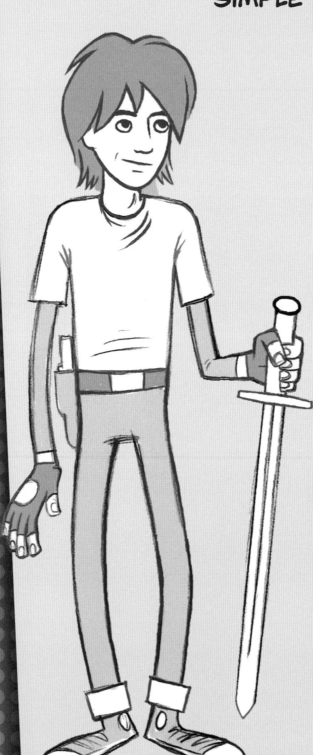

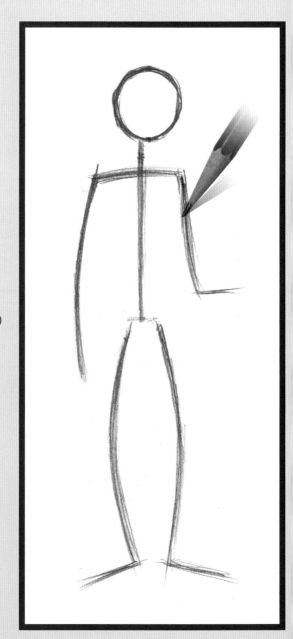

Use a light (hard) pencil for the rough layout: HB or H

The red lines show you what to draw next.

Now that you've learned to draw all the body basics, it's time to start drawing bodies in motion. Most books say you need to study anatomy to draw people. The characters we will draw are more cartoonish, so don't worry if things aren't perfect. As long as you have fun drawing, that's what really matters!

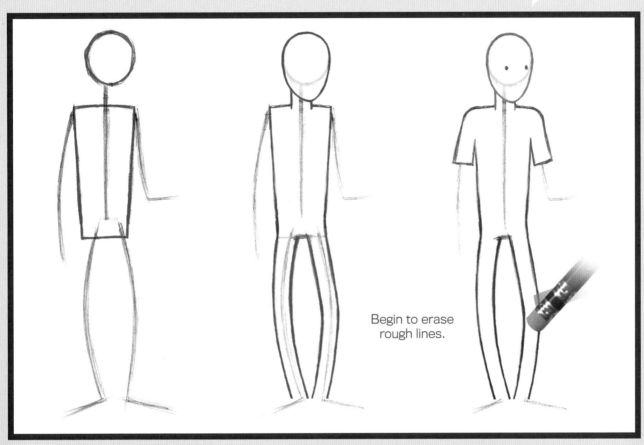

Begin to erase rough lines.

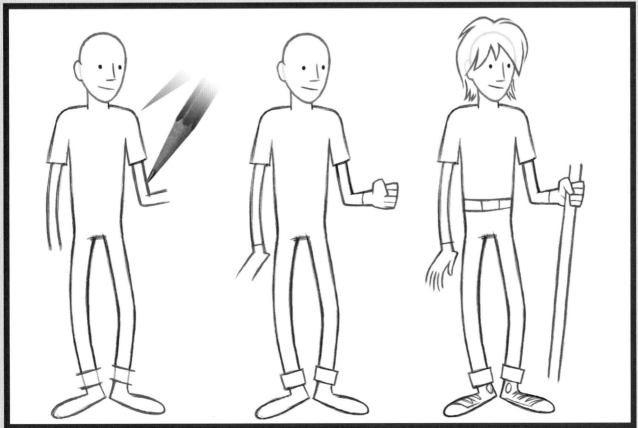

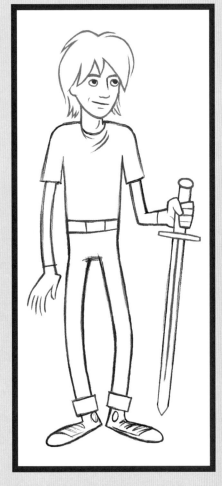
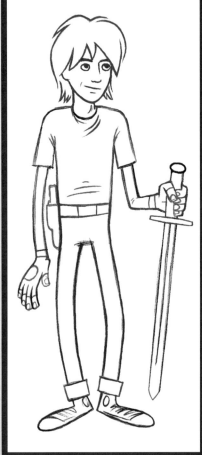
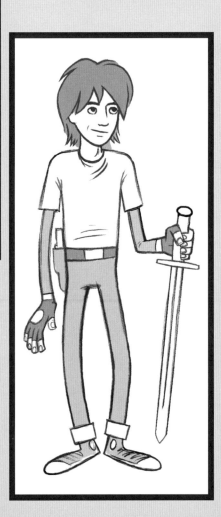

ACTION POSE

See, that wasn't so hard! Let's try another one, this time an action pose.

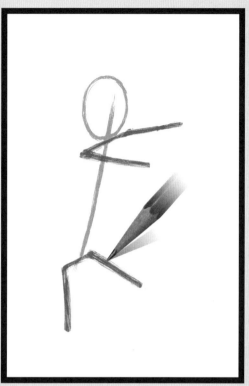
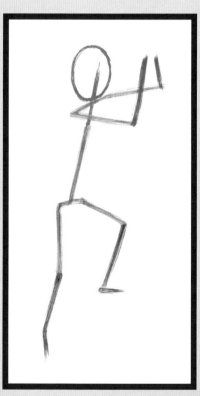
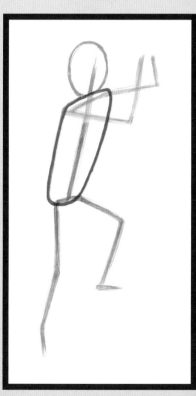
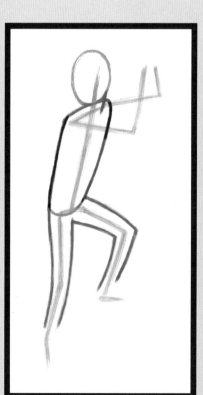

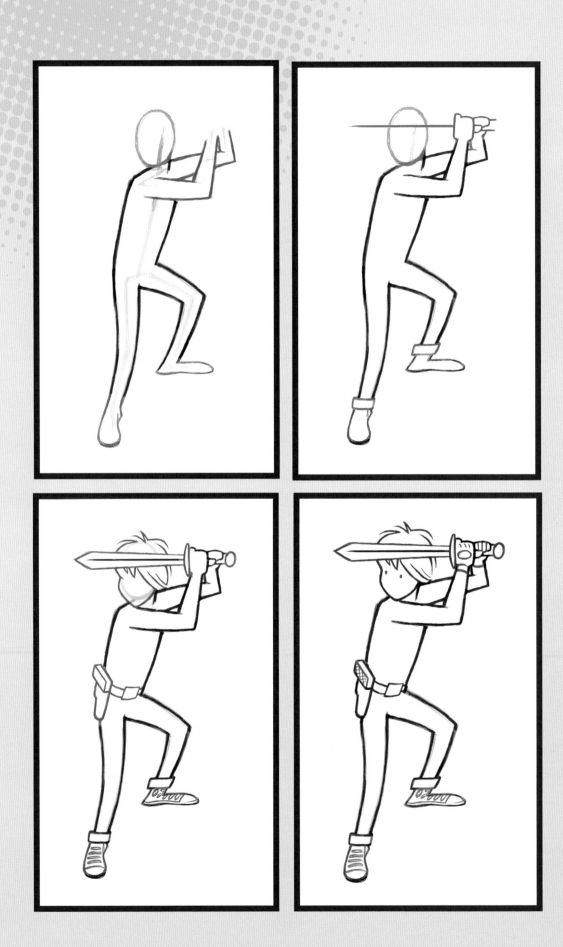

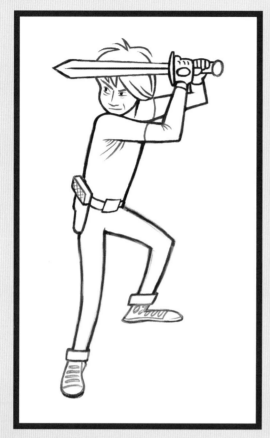

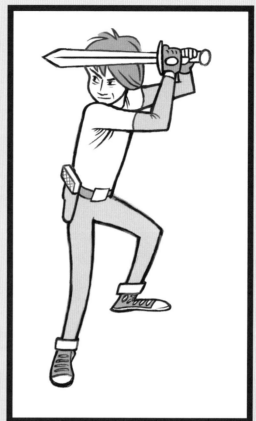

A good way to show movement in comics is with action lines. They can show where an object came from and where it's going.

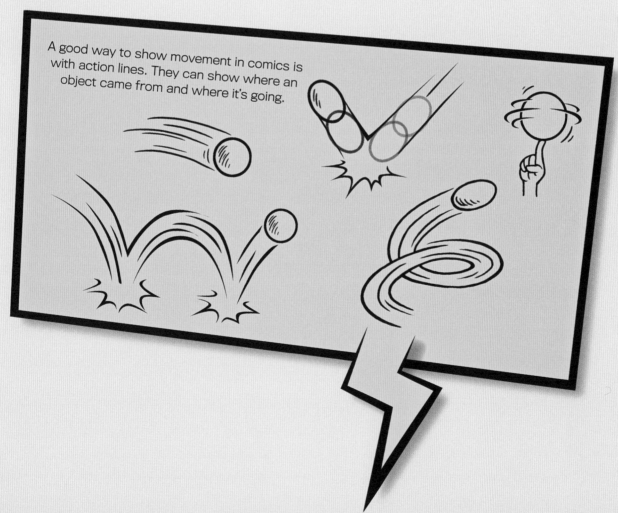

IT'S YOUR TURN!

Copy the character from pages 30-35 using different poses, faces, features, and gestures. The possibilities are endless!

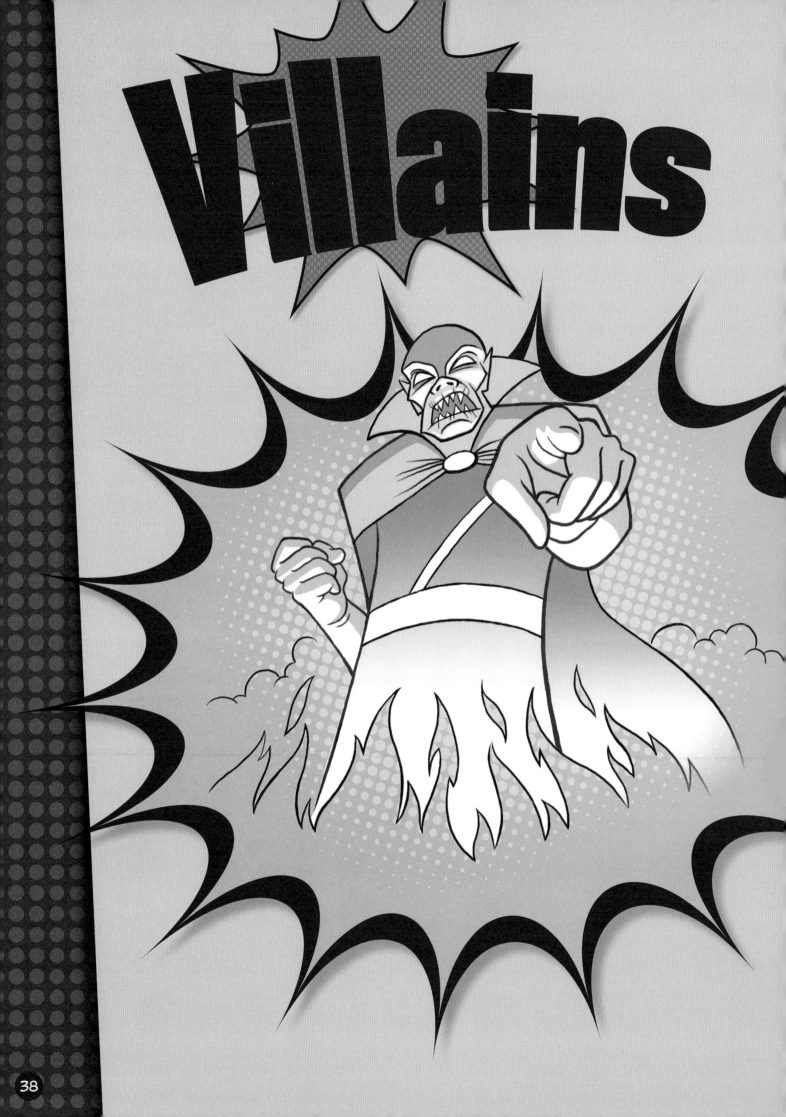

Every hero needs a nemesis to help him shine. Monster of the Deep? Raptor of the Skies? Whether human or animal, alien or beast, the origins of your villain will help you determine his shape and features.

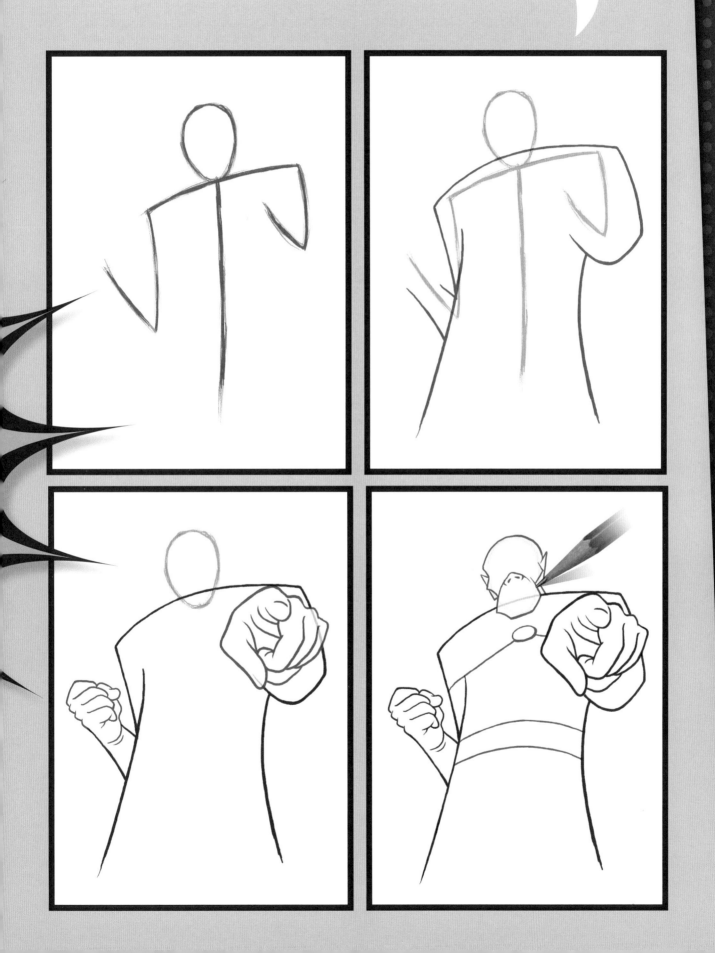

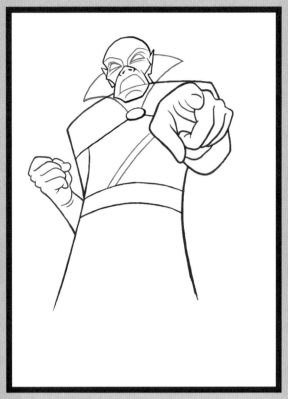

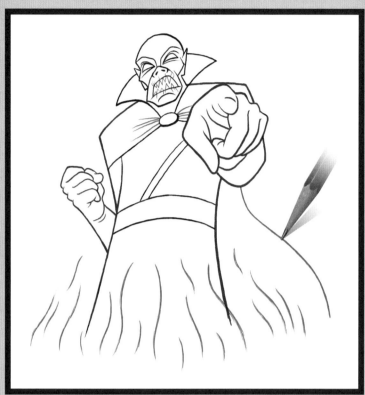

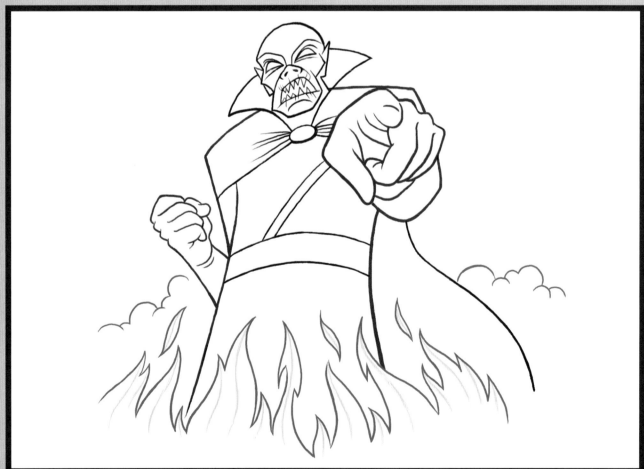

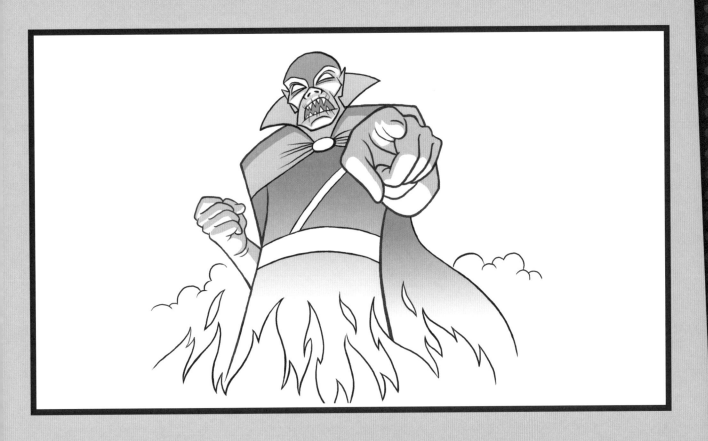

NOTES ABOUT FORESHORTENING

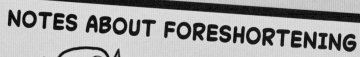

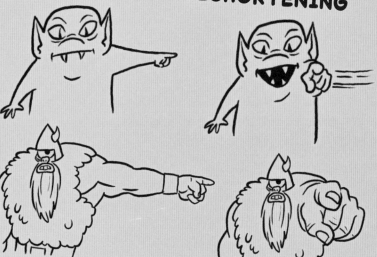

Foreshortening happens when something long is pointing straight at you and the length is hidden. If you're drawing a little guy with short arms, keep the hand small.

But with a big guy with long arms, make the hand much bigger. It increases the foreshortening effect.

CHARACTER DESIGNS

HEADS

The most important part about creating a head is the face. It says everything about the personality. The eyes, nose, ears, and mouth can be anyplace or nowhere at all. Below are a few examples of very different alien creatures created with the same basic shapes.

42

EYES

If you're going to draw eyes at all, the placement and size is important. Big bug eyes are good for brainy time travelers, whereas deep-set, hooded eyes depict more strength and dominance. Many alien eyes are drawn without pupils. This makes the creature look more mysterious. Drawing the two eyes different sizes creates a more deformed or mutated alien.

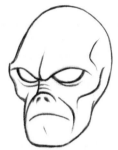 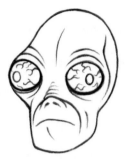 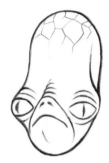 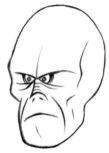

Deep-set, hooded eyes create a sinister, mysterious look.

For a crazier or insane look, try pushing the eyes outward, popping out of the head.

Lowering the eyes to nose level makes your creature more amphibious, or frog-like.

Placing very small eyes close together make for a dumb or easily frustrated character.

NOSES

Most artists ignore the nose when designing aliens, or they make it very small. Be different—add a prominent snout on your beast.

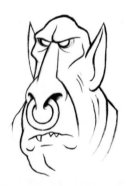 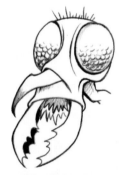 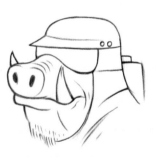 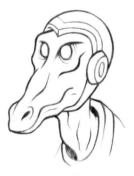

Big creatures are more likely to have a big nose. Add some nose jewelry to give him the look of an ancient race.

Insect aliens can have noses too. It's a good place to have a deadly stinger.

Don't be afraid to use animal noses on your aliens. This guy has the snout of a wild boar.

The head of a dino-reptilian character is almost all nose.

TEETH

Nothing makes a character more threatening than a mouthful of razor-sharp teeth. Fangs and such can be a little tricky at first. It's helpful to examine the skull of an actual predator, such as an alligator or tiger.

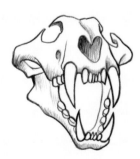 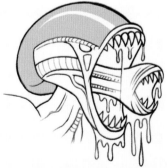

When drawing fangs, it helps to study the skull of an actual predator.

Crooked and chipped teeth with an under bite can look menacing.

Popular Hollywood aliens sometimes have a mouth within a mouth.

HANDS

Not all aliens have hands. But if you want to create them, here are some helpful hints: Smarter, less physically threatening creatures have long, skinny hands, which are more useful for operating computers and laser guns than for hand-to-hand combat. Two or three fingers are all he needs.

 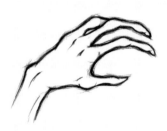

The giant hands of an alien warrior usually need good, sharp claws to help grab their victims. Sometimes they wear battle gear such as spiked leather wrist bands. The fingers are short and thick.

 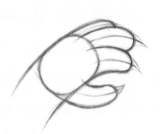 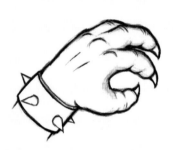 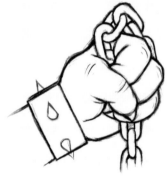

FEET

The feet are just as powerful as hands, but they're more vulnerable. Make sure you add some defensive armor.

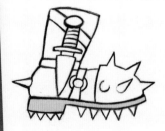 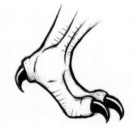

If an alien wears shoes, it's usually some kind of armored space boot with concealed weaponry or rocket boosters.

In the wastelands of distant planets, aliens need good, strong feet. Warriors need large claws for fighting. Many times, dinosaur feet work well.

Planets covered with slime and goo are where you can find creatures with high-traction spikes. Leave the ends open if you want them to shoot poison rockets.

If a droid loses a leg, it can easily be defeated. They need special armor to stay mobile. If wheels are used, they need to be concealed.

SETTING UP YOUR SCENE

When setting up your scene in a drawing or comic, you're doing the same job as any famous movie director. It's important that your audience sees exactly what you want them to see, in the best way possible. Try to imagine that you are viewing the comic book panel through the lens of a camera. The position of the camera has a huge impact on the feeling of the scene. The illustration below shows how one scene can have a completely different feel just by changing camera angles.

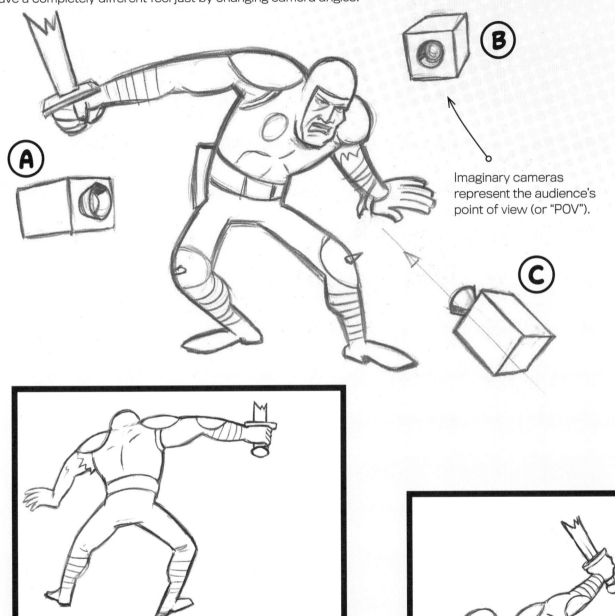

Imaginary cameras represent the audience's point of view (or "POV").

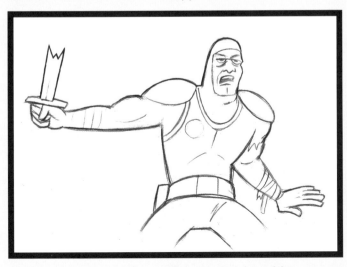

A) The focus could be on his opponent.

B) Your character looks smaller, more vulnerable.

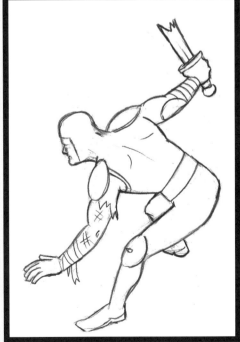

C) Your character looks bigger, more powerful.

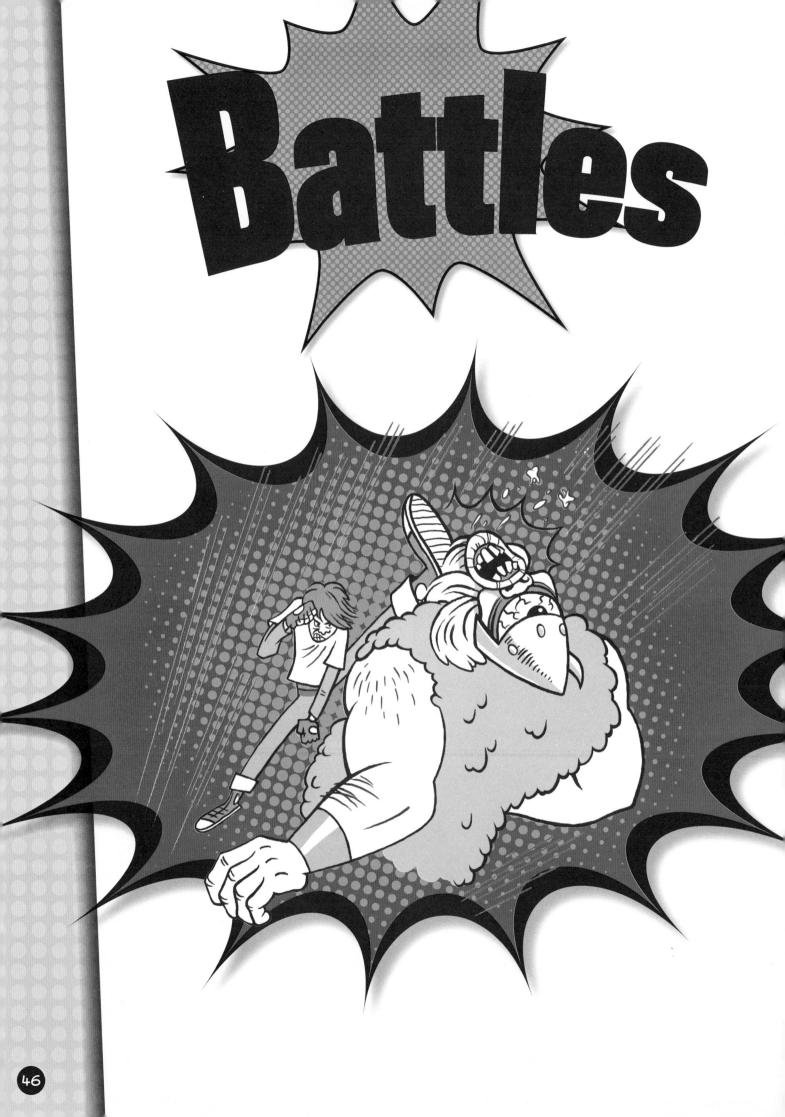

Now let's try drawing an action-packed
battle scene with a hero and a villain.

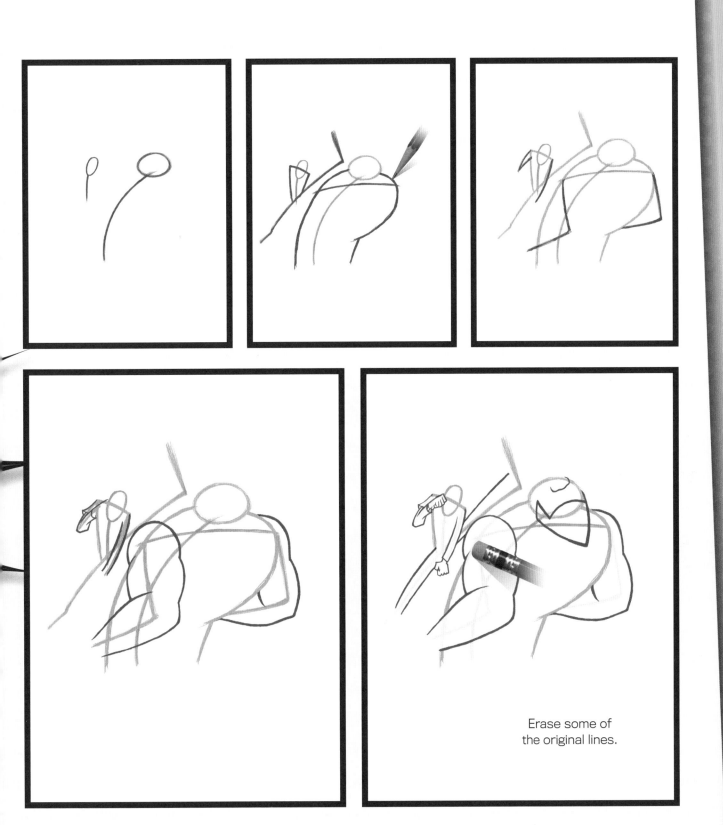

Erase some of
the original lines.

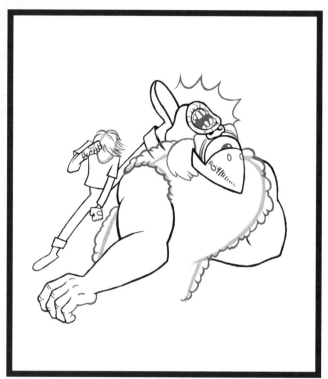

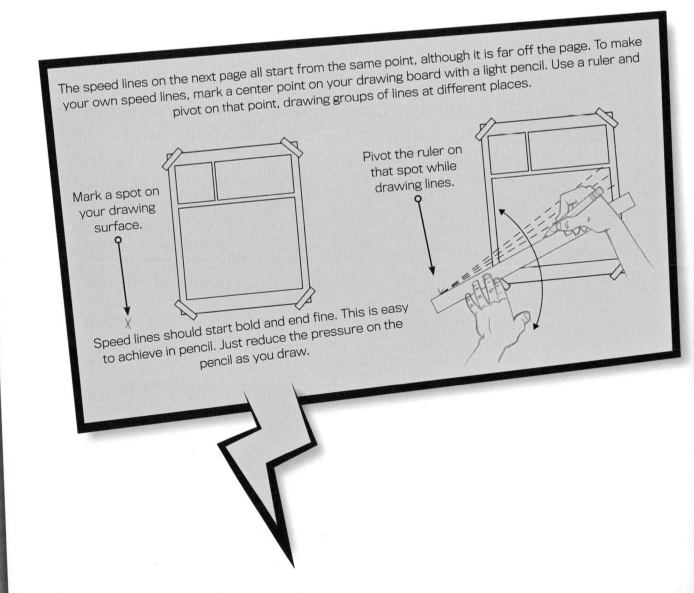

The speed lines on the next page all start from the same point, although it is far off the page. To make your own speed lines, mark a center point on your drawing board with a light pencil. Use a ruler and pivot on that point, drawing groups of lines at different places.

Mark a spot on your drawing surface.

Pivot the ruler on that spot while drawing lines.

Speed lines should start bold and end fine. This is easy to achieve in pencil. Just reduce the pressure on the pencil as you draw.

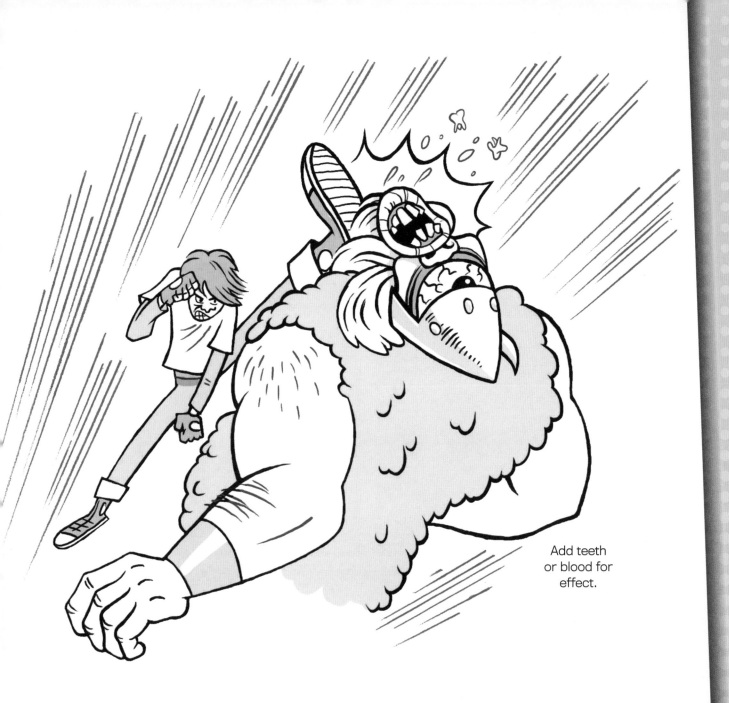

Add teeth
or blood for
effect.

ARTIST'S TIP
Japanese illustrators use speed lines to add action to a scene. They're easier to make than you think! Try adding them to your artwork.

IT'S YOUR TURN!

Brainstorm your own epic villain in the space below, and create a battle scene using foreshortening and speed line tricks.

Building Comic Characters

Several stereotypes recur throughout the history of comics. These stereotypes are often interchangeable. The big guy in the center could easily be cast as a heroic giant or a monstrous hulk—we often see super-villains that are as heroic in stature as their good-guy counterparts. The combinations are endless—have fun mixing characters and attributes up in new and interesting ways!

PROPORTIONS

Establishing your character's proportions is important. Artists often use a character's head as a unit of measurement to establish the general body type. Most humanoid characters have roughly the same head size. For example, a typical hero measures 7 to 8 heads high; a teenage sidekick might be 5½ heads high, while a child, or super-powered alien with childlike proportions, might be about 3½ heads high.

At right is a typical superhero couple. You can see that the man is about 7½ heads high, and the woman is about 7 heads high.

These guidelines aren't rigid rules but a rough framework to help you create characters and keep them consistent from drawing to drawing. Much depends on your personal preference and what looks best for your style and character.

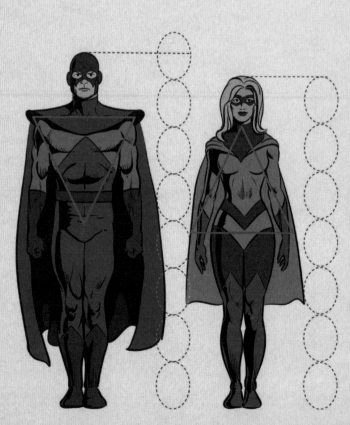

PLAYING WITH PROPORTIONS

At right are three figures with the same head size, but with bodies of different proportions. The figure on the left has heroic proportions of 7½ heads high. He could pass for an average human and a super. The guy in the middle has typical child proportions—about 4 heads high. The last figure is 8½ heads high. He could easily be seen as gigantic in proportion (when compared to the figure on the left). By himself he would make a very strong heroic figure.

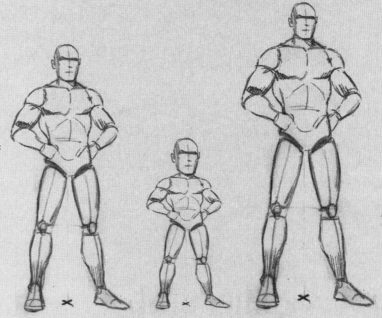

DRAWING THE FIGURE IN SPACE

Drawing your heroes and villains in static poses probably isn't something you'll be doing in your comic—especially if you write comics with a lot of action! It's important to practice drawing your characters from different angles and perspectives. The easiest way to visualize the figure in space is to use simple cylinders to draw the various parts of the body. The sketches below are just a few examples of possible angles and perspectives and illustrate how these simple forms can be used to build up complex and interesting poses.

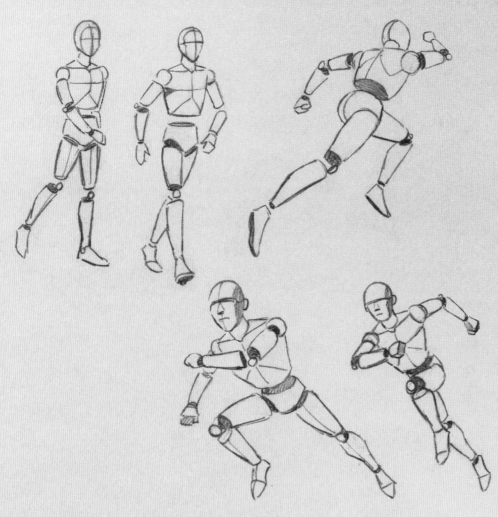

CHARACTER STYLING

Over the past couple decades, more and more superheroes have been featured on television as animated cartoons. Animation requires simplified character design in order to draw thousands of images per episode. Eventually this cartoon styling started to creep back into the printed versions of superheroes. Today it is common to see comics of your favorite character rendered in animation style. This style gives the comic book artist even more flexibility and expression when drawing stories.

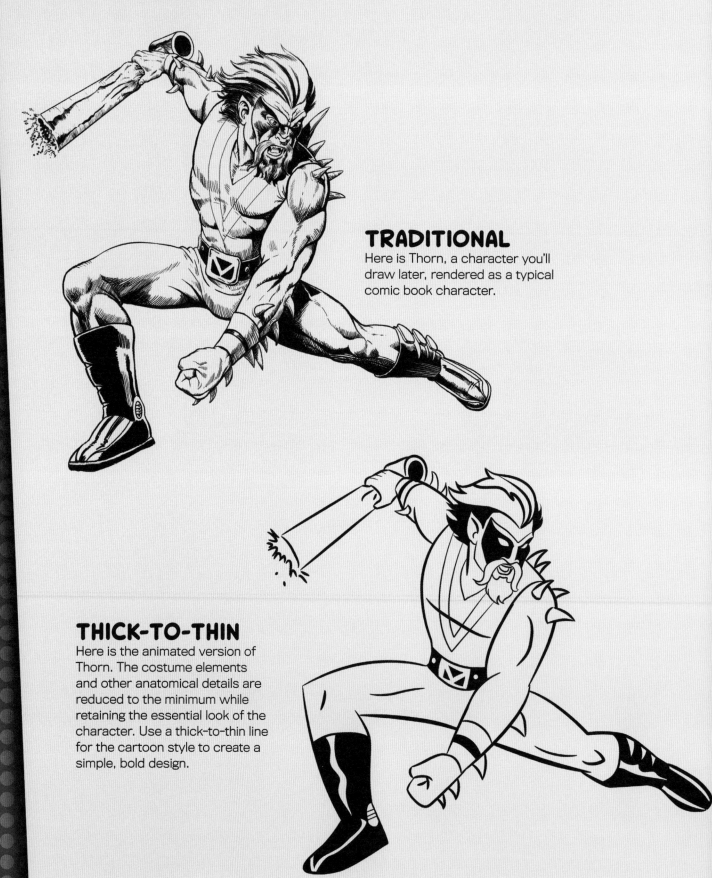

TRADITIONAL

Here is Thorn, a character you'll draw later, rendered as a typical comic book character.

THICK-TO-THIN

Here is the animated version of Thorn. The costume elements and other anatomical details are reduced to the minimum while retaining the essential look of the character. Use a thick-to-thin line for the cartoon style to create a simple, bold design.

EXAGGERATED

The design is even more exaggerated and fluid. The weight of the line work is reduced to a minimum width and has little or no variation.

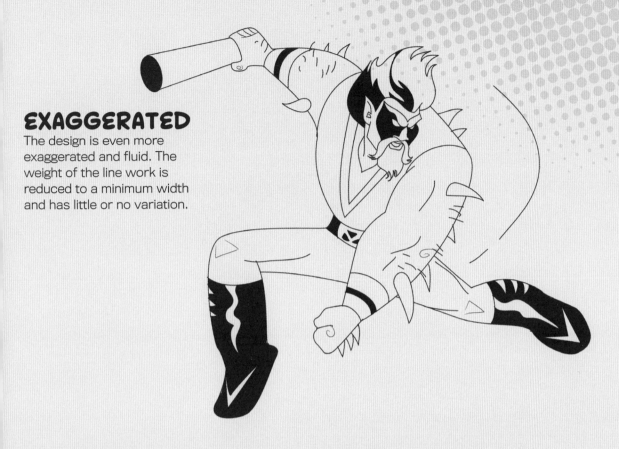

COLORIZED

Here are the cartoon versions of Thorn in color. Compare these to the final step for Thorn on page 97. See the difference?

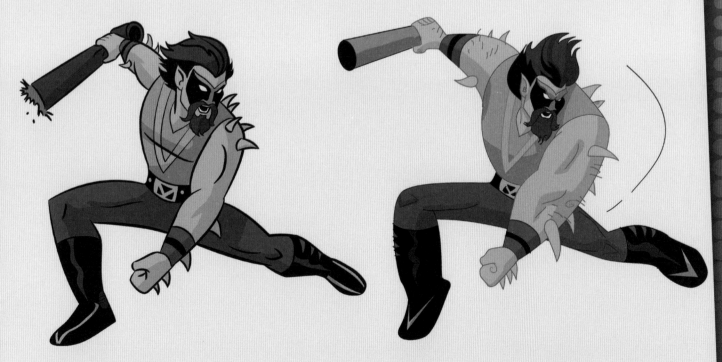

In comics there is no limit to your imagination. You can design and draw your characters in a number of ways, and your characters can possess powers that are figments of your unique imagination. The main thing is to entertain your reader and yourself...and have fun creating your own comics!

Bionic Hero

STEP I

Briskly sketch a wire frame. Draw in the head, main body masses, and arms and legs. Focus on proportion and balance. Work freely and lightly; your drawing will take on more detail as you progress to each step.

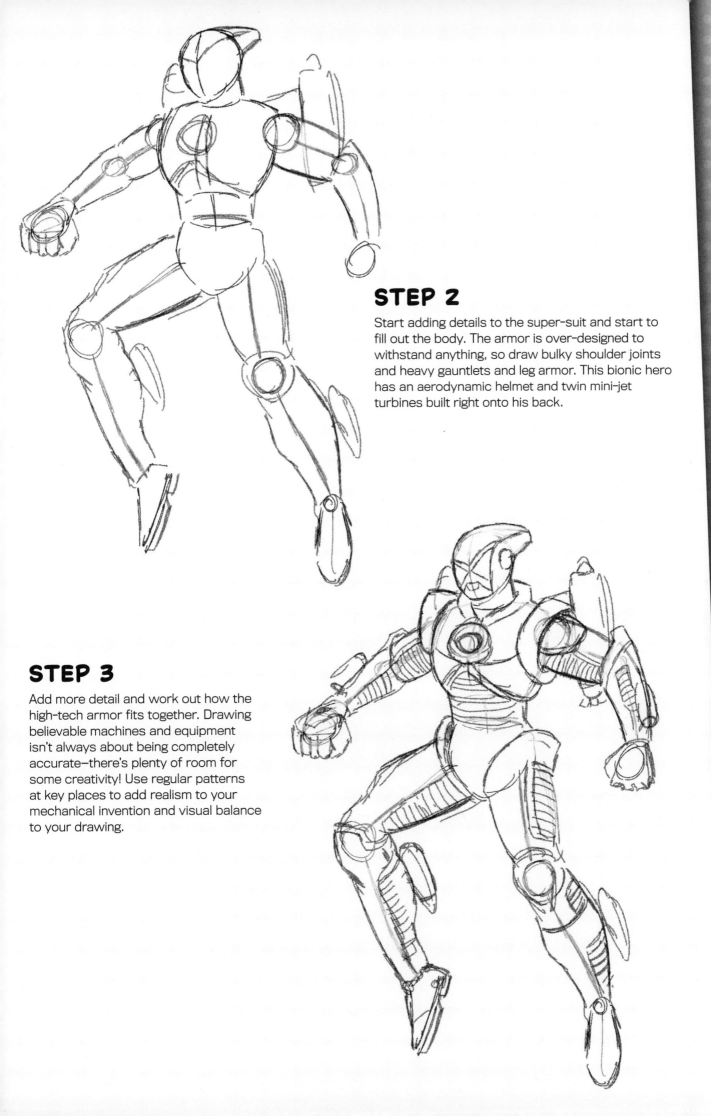

STEP 2

Start adding details to the super-suit and start to fill out the body. The armor is over-designed to withstand anything, so draw bulky shoulder joints and heavy gauntlets and leg armor. This bionic hero has an aerodynamic helmet and twin mini-jet turbines built right onto his back.

STEP 3

Add more detail and work out how the high-tech armor fits together. Drawing believable machines and equipment isn't always about being completely accurate—there's plenty of room for some creativity! Use regular patterns at key places to add realism to your mechanical invention and visual balance to your drawing.

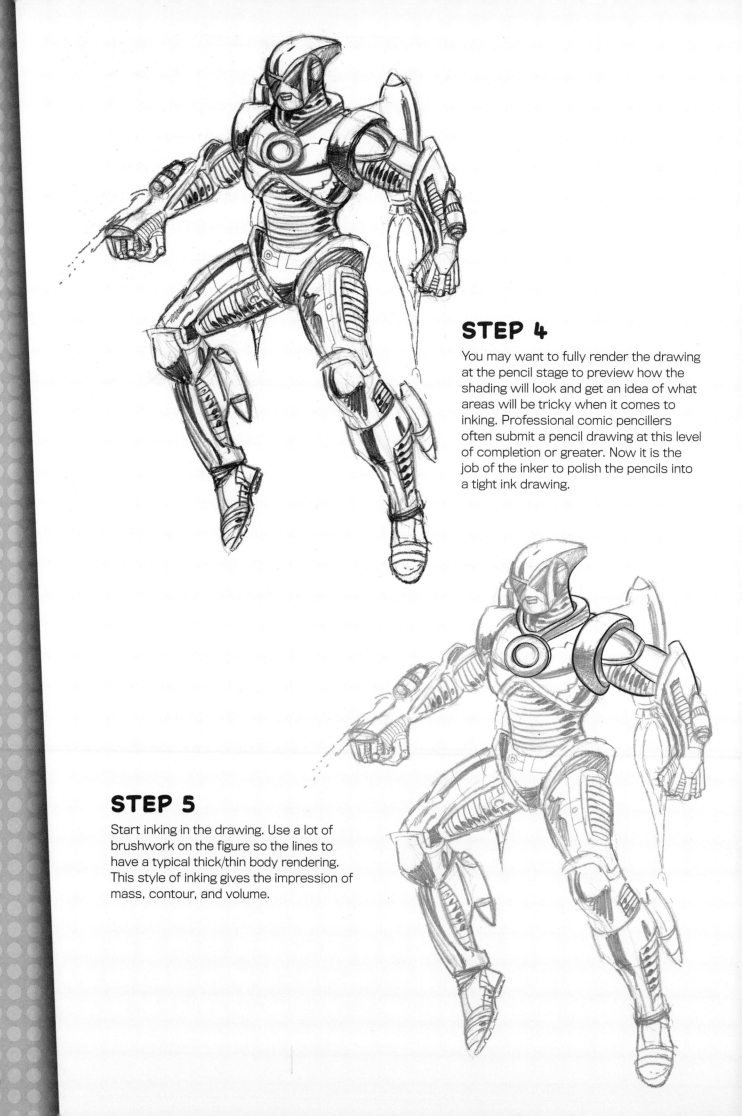

STEP 4

You may want to fully render the drawing at the pencil stage to preview how the shading will look and get an idea of what areas will be tricky when it comes to inking. Professional comic pencillers often submit a pencil drawing at this level of completion or greater. Now it is the job of the inker to polish the pencils into a tight ink drawing.

STEP 5

Start inking in the drawing. Use a lot of brushwork on the figure so the lines to have a typical thick/thin body rendering. This style of inking gives the impression of mass, contour, and volume.

STEP 6

Work around the drawing to keep the
process fresh and fun. Tackle any
design issues, adding a lot more detail
and using actual human musculature
as inspiration.

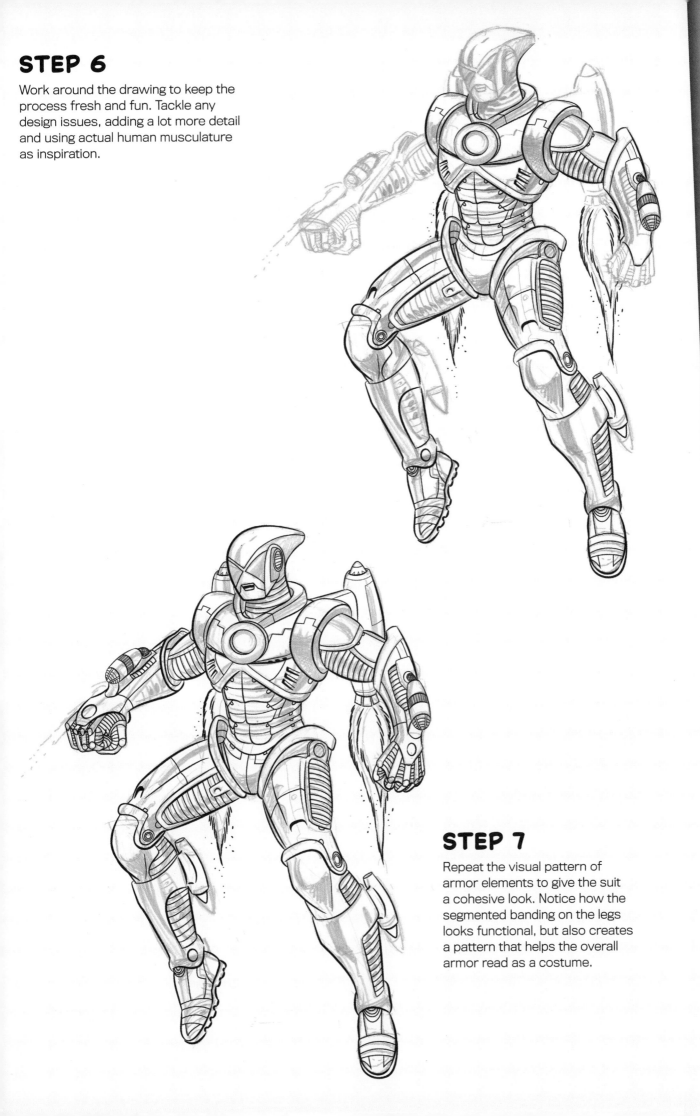

STEP 7

Repeat the visual pattern of
armor elements to give the suit
a cohesive look. Notice how the
segmented banding on the legs
looks functional, but also creates
a pattern that helps the overall
armor read as a costume.

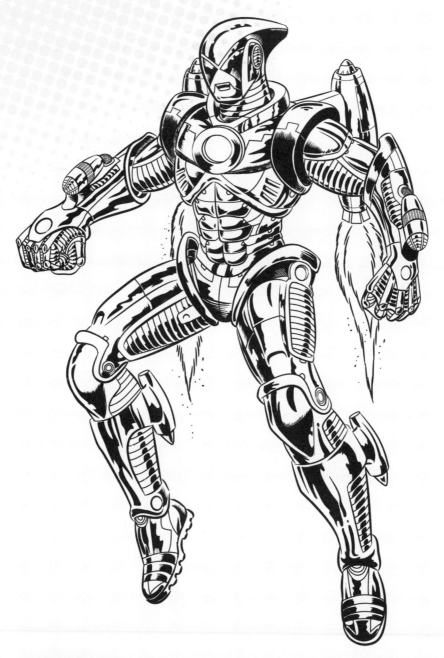

STEP 8

In the real world, shine on metallic objects is a reflection of light and darker areas. Comics use shorthand to give the viewer a visual cue that an object is shiny. High-contrast areas of squiggly black shapes are one of those tried-and-true conventions. But it isn't just simply adding squiggly lines; note that black shapes also suggest shadow and form, especially around the shoulder joints, torso, and lower legs.

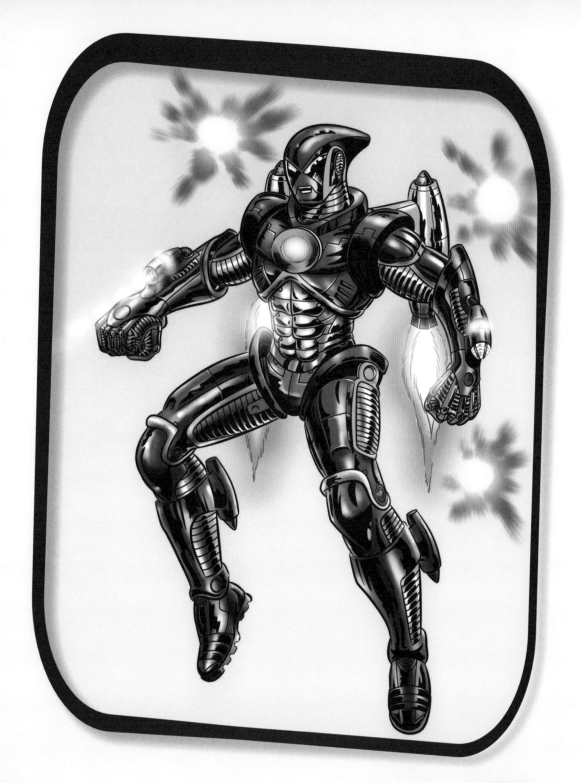

STEP 9

There are many ways to color artwork for comics. Today the preferred method among professionals is digital coloring, using digital paint programs such as Photoshop®. If you don't have this technology, a low-tech way to achieve similar results is to photocopy your inked drawing on a very good laser photocopier and use alcohol-based markers to color in the photocopy.

ARTIST'S TIP

Take into account various light sources when you're coloring. In particular, notice the hot orange-yellow glow from the flames reflecting on the surface of the hero's armor. This not only adds additional drama to your art, but also dimension and believability.

The Red Wraith

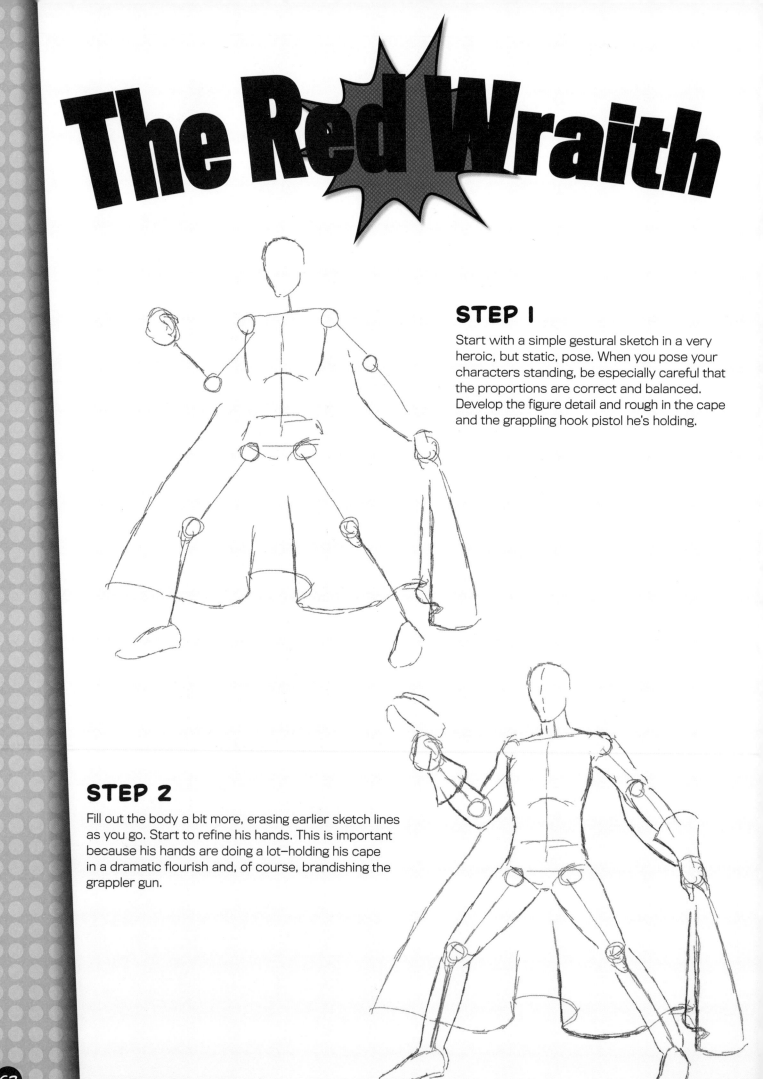

STEP 1

Start with a simple gestural sketch in a very heroic, but static, pose. When you pose your characters standing, be especially careful that the proportions are correct and balanced. Develop the figure detail and rough in the cape and the grappling hook pistol he's holding.

STEP 2

Fill out the body a bit more, erasing earlier sketch lines as you go. Start to refine his hands. This is important because his hands are doing a lot–holding his cape in a dramatic flourish and, of course, brandishing the grappler gun.

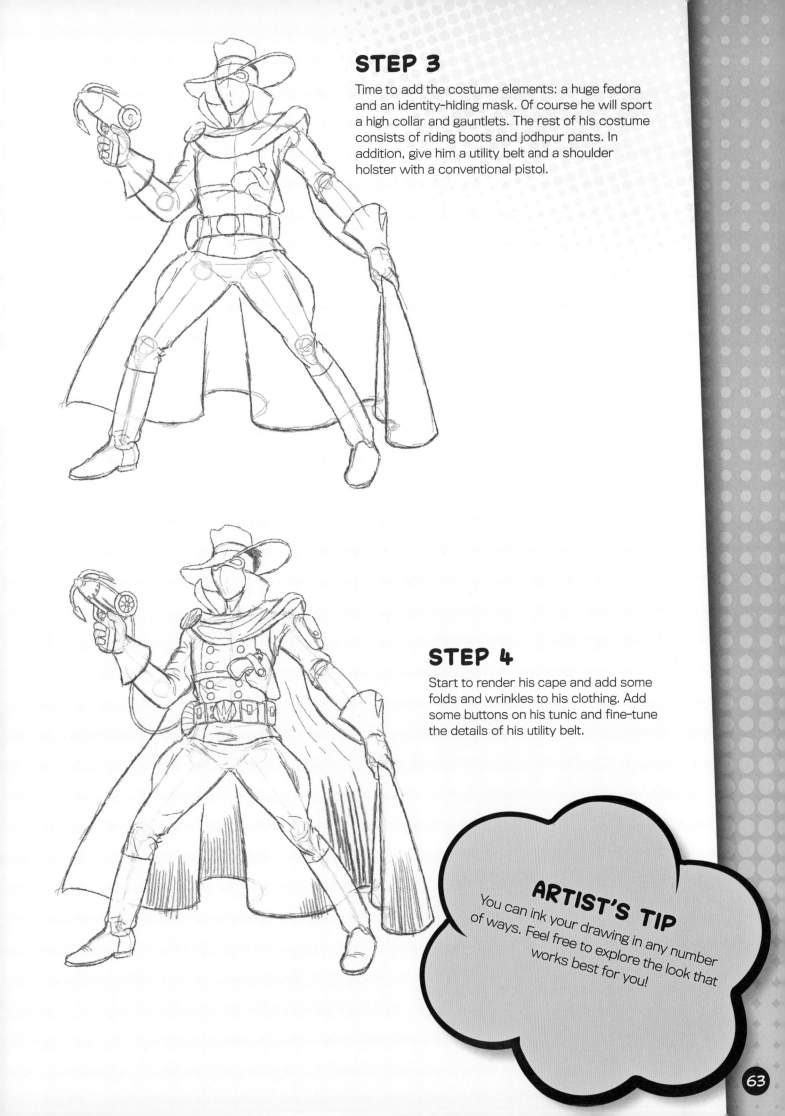

STEP 3

Time to add the costume elements: a huge fedora and an identity-hiding mask. Of course he will sport a high collar and gauntlets. The rest of his costume consists of riding boots and jodhpur pants. In addition, give him a utility belt and a shoulder holster with a conventional pistol.

STEP 4

Start to render his cape and add some folds and wrinkles to his clothing. Add some buttons on his tunic and fine-tune the details of his utility belt.

ARTIST'S TIP

You can ink your drawing in any number of ways. Feel free to explore the look that works best for you!

STEP 5

Fill in the darkest areas. Even though this work will be covered with ink, it helps to visualize the final drawing.

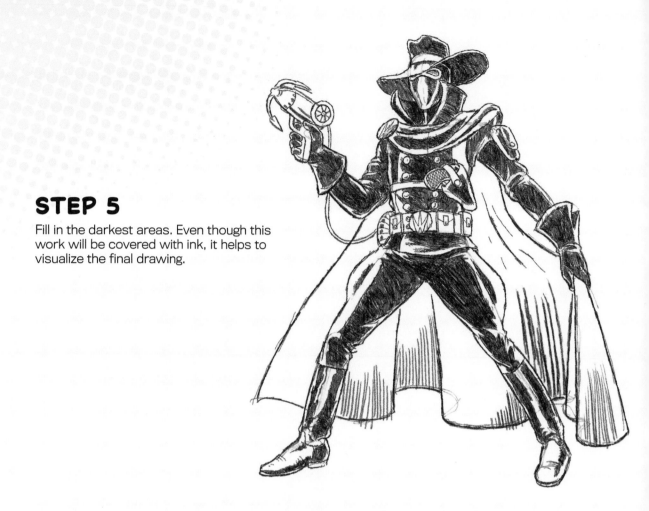

STEP 6

Start to draw the final ink lines with a very fluid brush line. When you draw clothing that isn't standard superhero spandex, have fun with the folds and be aware of how the position of the figure deforms the outer clothing.

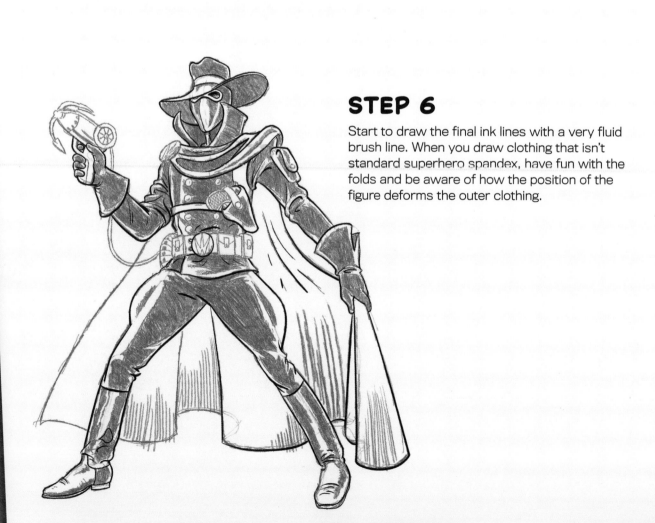

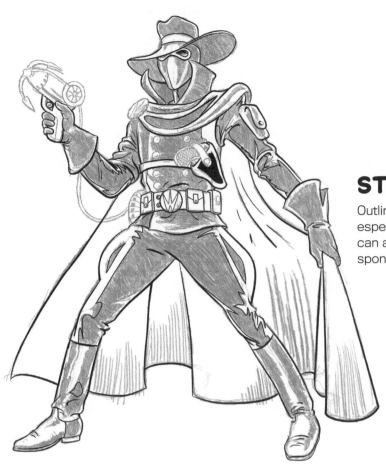

STEP 7

Outline the shapes of the darkest shadow, especially when there is a lot of black. You can also ink dark shadows a little more spontaneously with a larger brush.

STEP 8

Fill in the rest of the outlined shapes. The crisp black shapes not only punch up the image, but also define the form of the Red Wraith.

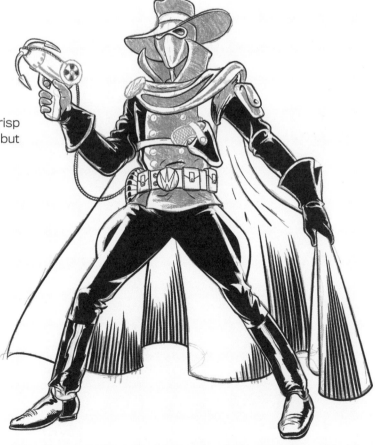

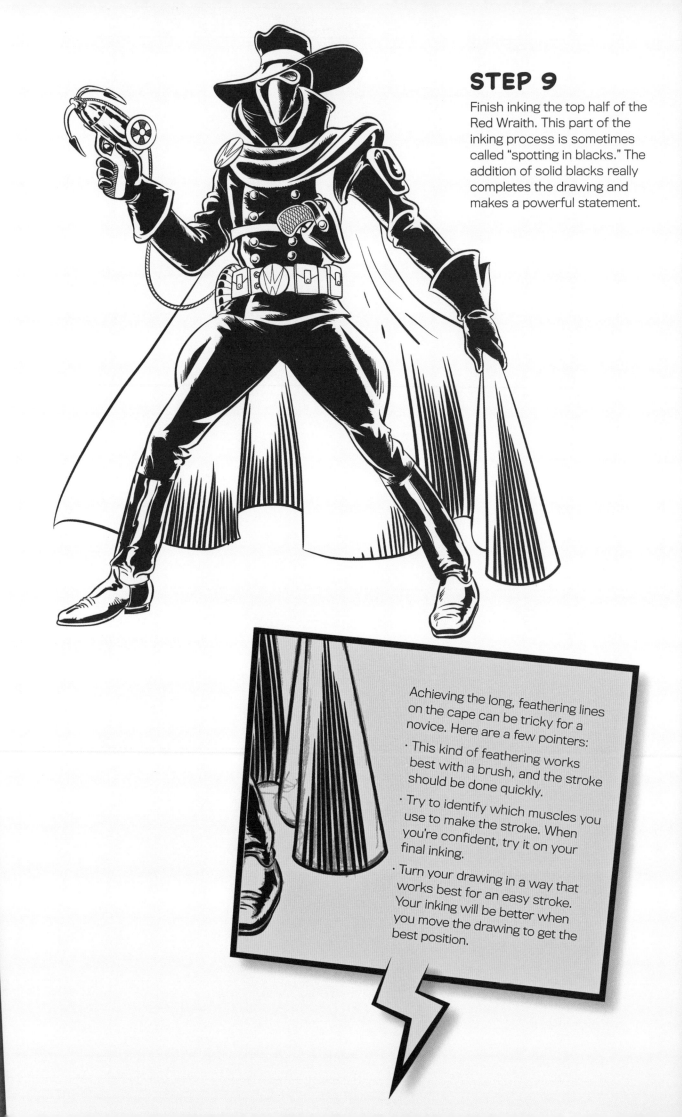

STEP 9

Finish inking the top half of the Red Wraith. This part of the inking process is sometimes called "spotting in blacks." The addition of solid blacks really completes the drawing and makes a powerful statement.

Achieving the long, feathering lines on the cape can be tricky for a novice. Here are a few pointers:

· This kind of feathering works best with a brush, and the stroke should be done quickly.

· Try to identify which muscles you use to make the stroke. When you're confident, try it on your final inking.

· Turn your drawing in a way that works best for an easy stroke. Your inking will be better when you move the drawing to get the best position.

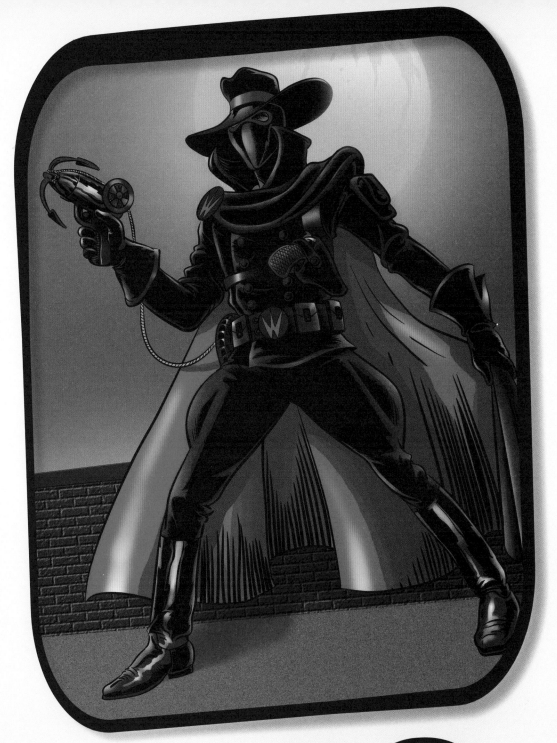

STEP 10

Place the Red Wraith on a nondescript rooftop at night (of course), with the city lights peeping over the edge of the roof and a huge baleful moon partially silhouetting him.

ARTIST'S TIP

The beauty of digital paint programs is that you can add much more depth and polish to even your most polished ink drawings. If you can purchase and learn a program like Photoshop, you'll be glad you did. It will take your art to a whole new level.

Evil Genius

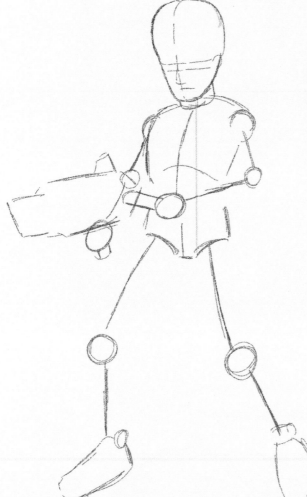

STEP 1

Start with a fairly straightforward stance. Evil Genius's power is in his inventions, not his stature. Physically, he's unremarkable—except, of course, for his super-sized cranium. Using a light pencil, rough out his figure in simple lines and shapes.

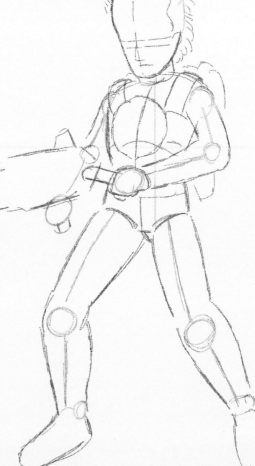

STEP 2

Start to block out some of the form of his exoskeleton and particle gun and start drawing guidelines for his face.

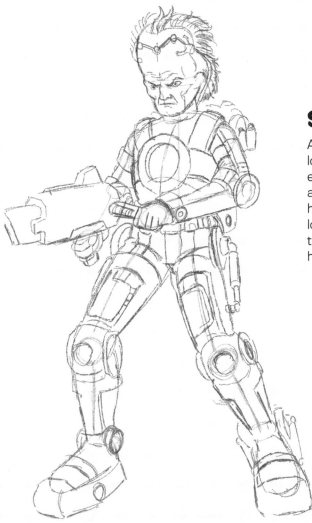

STEP 3

Add a scowl to his face and begin to locate the various jointed details of his exo-suit. Note the mechanical details added to bring a little more realism to his exo-suit, specifically the pistons located at the hip and ankle joints and the segmented bands that run along his arms.

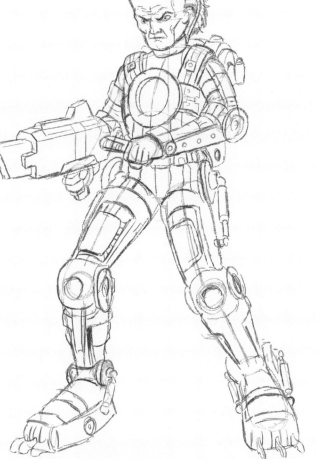

STEP 4

Continue to add mechanical detail. This step is part texture design and part mechanical invention. The suit details don't need to be accurate, but they do need to look believable and interesting. Since you'll be inking over this sketch, keep things fairly loose at this point and save some of the fun for the inking phase.

STEP 5

An artist pen is the perfect tool for this kind of character, but you can also use a brush or quill if you have refined your skills. The important thing is to work carefully and think about line quality as you draw the detail.

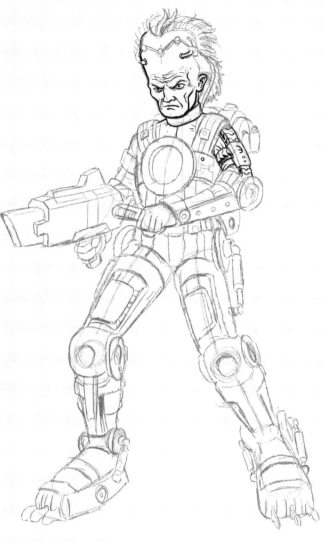

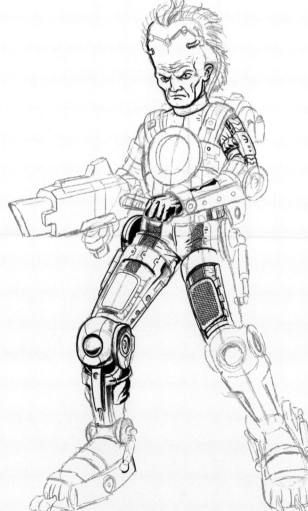

STEP 6

To suggest hard-edged metallic objects, use a line with a uniform weight, making thinner strokes on the underside of objects to suggest lighting. For rounded objects, bend this rule a little, using a gentle line variation to suggest roundness. In the face and fabric, use a pen brush for variation that suggests softer, more flexible properties.

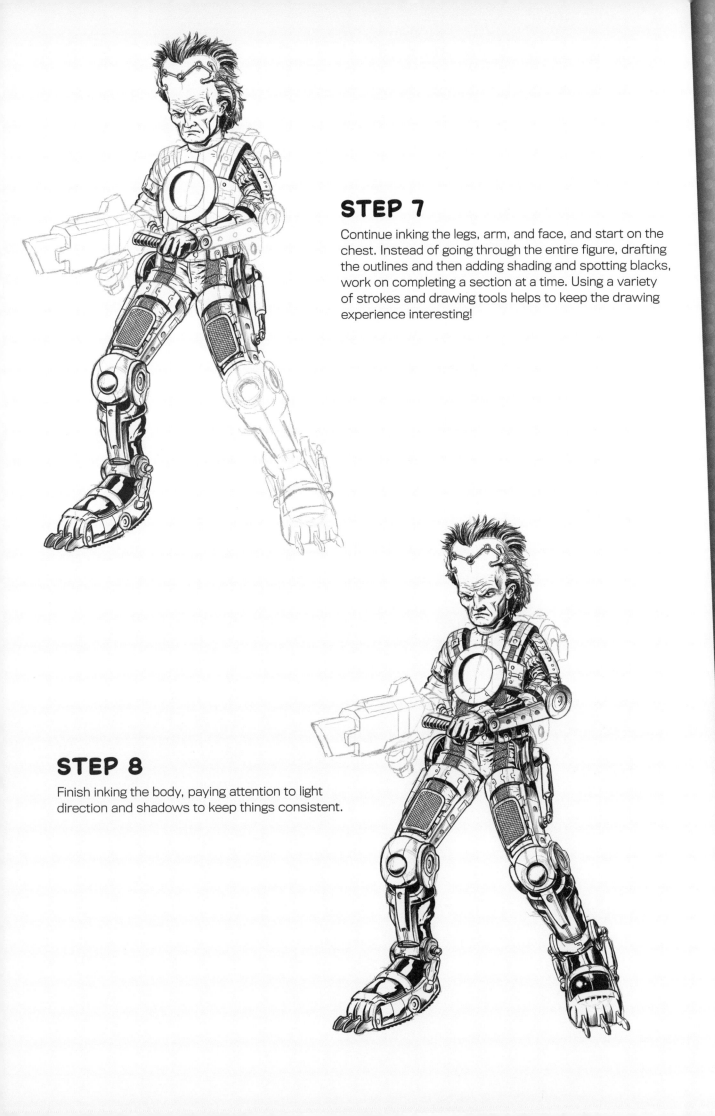

STEP 7

Continue inking the legs, arm, and face, and start on the chest. Instead of going through the entire figure, drafting the outlines and then adding shading and spotting blacks, work on completing a section at a time. Using a variety of strokes and drawing tools helps to keep the drawing experience interesting!

STEP 8

Finish inking the body, paying attention to light direction and shadows to keep things consistent.

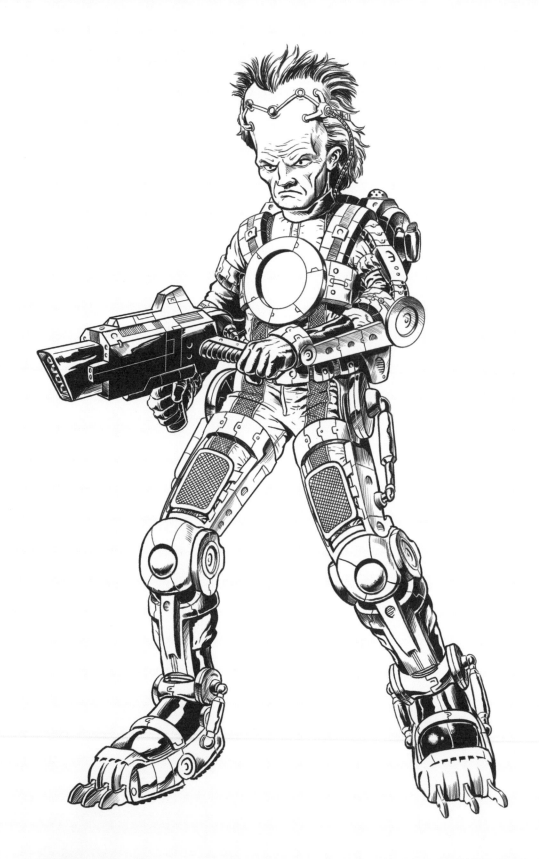

STEP 9

Complete the inking, using a very high-contrast inking scheme for the particle cannon and Evil's backpack. Use white lines for some of the seams on the cannon. This allows the details to follow through the varying shaded areas and still look like a solid, mechanical object. Create these white lines either by inking around a black line and keeping one side white, or—if you have a steady hand—loading a brush, quill pen, or mechanical drafting pen with diluted white paint.

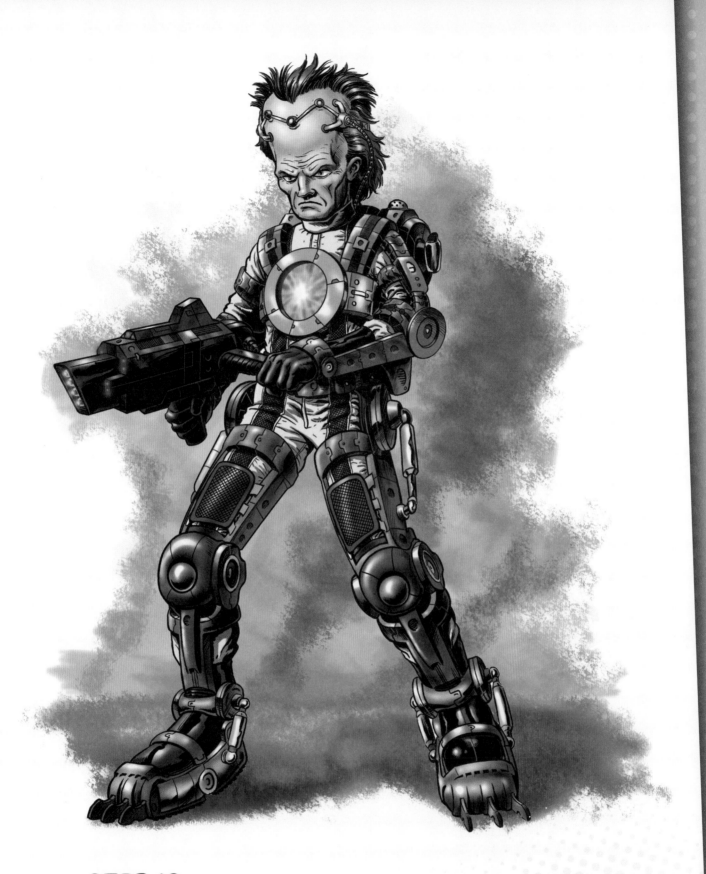

STEP 10

Scan the drawing and use Photoshop to color the final rendering. For shading on metallic areas, such as his exo-suit, use a combination of the dodge and burn tools, which achieves a very realistic metal effect. For other shading, use variations of the base color for highlights and shadows.

STEP 1

Draw Ninja Warrior in mid-jump, brandishing her pistol and reaching for her sword. Rough out her position and major body masses, arms, and legs.

STEP 2

Begin sketching and building her form over the loose figure. Treat the various parts of the anatomy as a collection of cylinders or simple shapes that you can easily visualize. There are tricky elements to this pose, particularly the foreshortening on her left leg and her right hand, which is reaching back to her sword. Draw the sword through her body to make sure that the two ends match up.

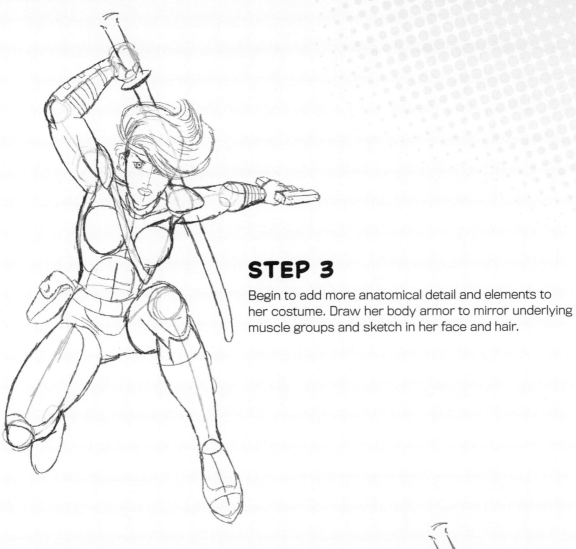

STEP 3

Begin to add more anatomical detail and elements to her costume. Draw her body armor to mirror underlying muscle groups and sketch in her face and hair.

STEP 4

Work out the black areas in pencil first. The first pass establishes the direction of light and some preliminary marks to suggest the shiny metal of some of her armor plating.

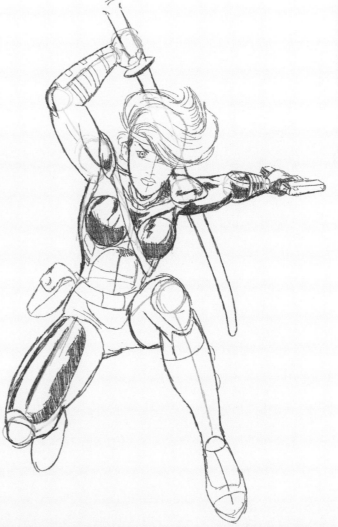

STEP 5

Complete the sketch, adding the underlying crosshatched texture to her costume and areas of deep shadow.

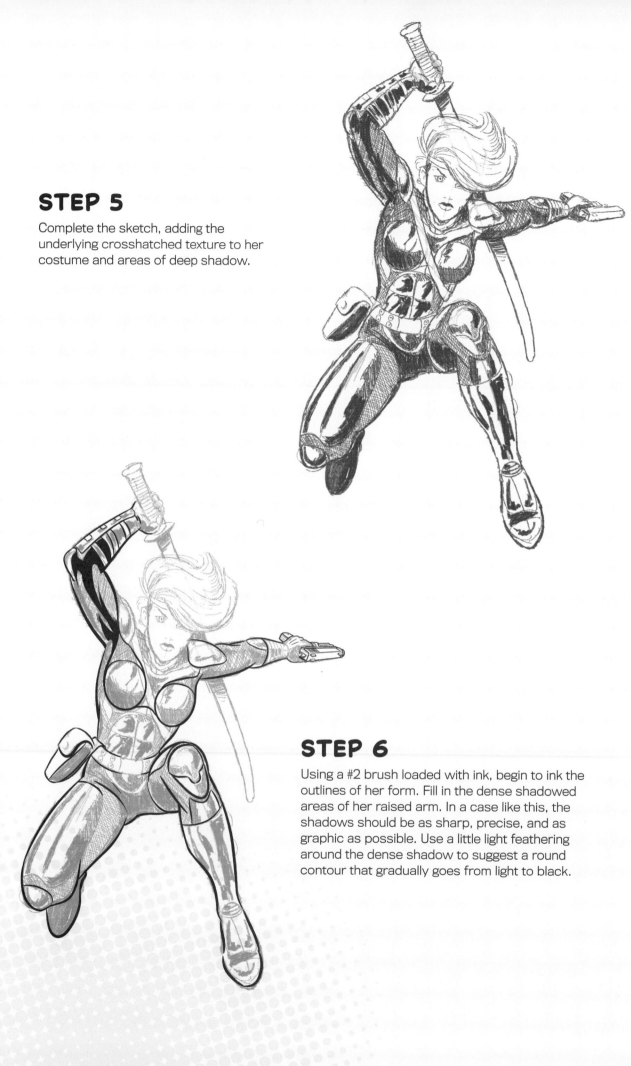

STEP 6

Using a #2 brush loaded with ink, begin to ink the outlines of her form. Fill in the dense shadowed areas of her raised arm. In a case like this, the shadows should be as sharp, precise, and as graphic as possible. Use a little light feathering around the dense shadow to suggest a round contour that gradually goes from light to black.

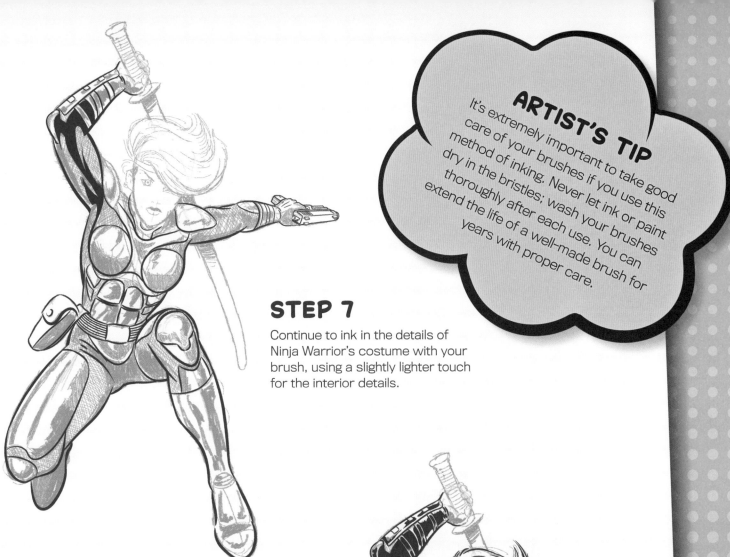

STEP 7

Continue to ink in the details of Ninja Warrior's costume with your brush, using a slightly lighter touch for the interior details.

STEP 8

Continue inking, outlining the darkest areas and carefully filling them in with the brush. Occasionally, you may need to switch to an art pen. You can also use a quill, but ink from a quill tends to be thicker, takes longer to dry, and leaves a slightly raised surface.

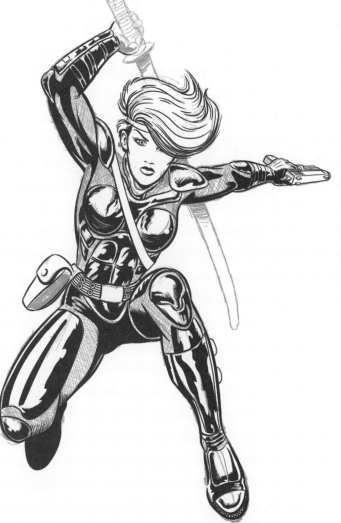

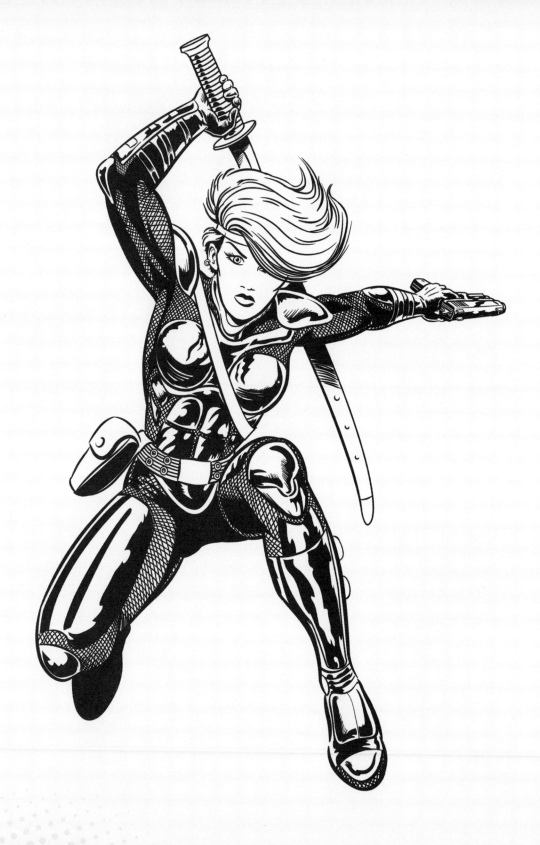

STEP 9

Draw in the crosshatched pattern of her costume with a fine art pen. Then ink in her face with a brush but restrain from adding a lot of shading or hatch.

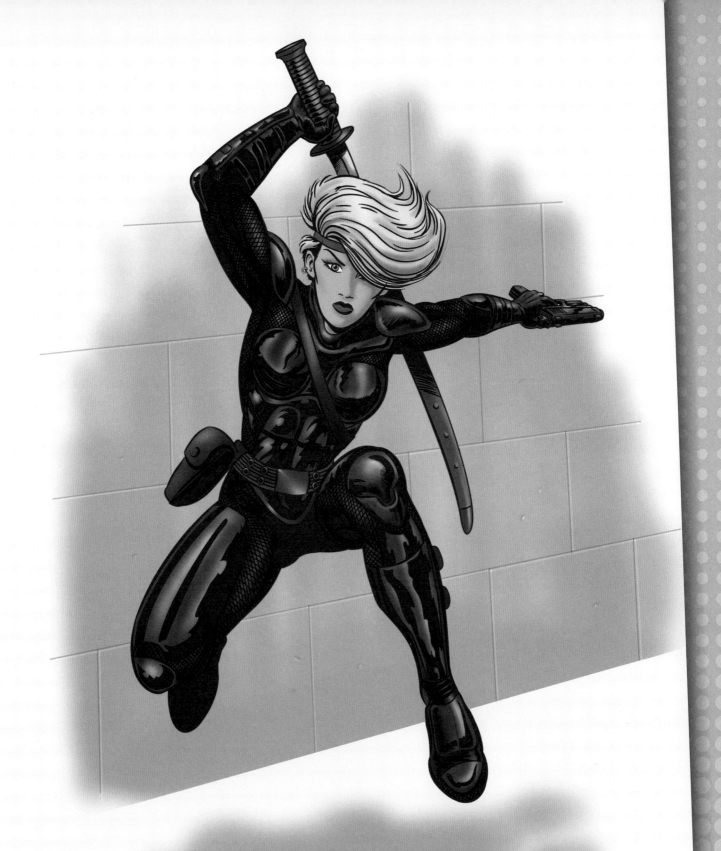

STEP 10

You can scan the image into Photoshop and color it, but markers will work just as well. Take some time tweaking the various colors of her costume. While the overall impression of her costume should be black, the actual colors are a very dark purple-gray, a dark gray-brown, and 85% black.

Megaguy

STEP 1

Start with a simple stick figure sketch, using a soft #2 pencil.

STEP 2

Rough in the muscle contours of the figure. Then add rough details in the costume, such as his belt, boots, cape, and gloves. Start to erase the initial sketch lines.

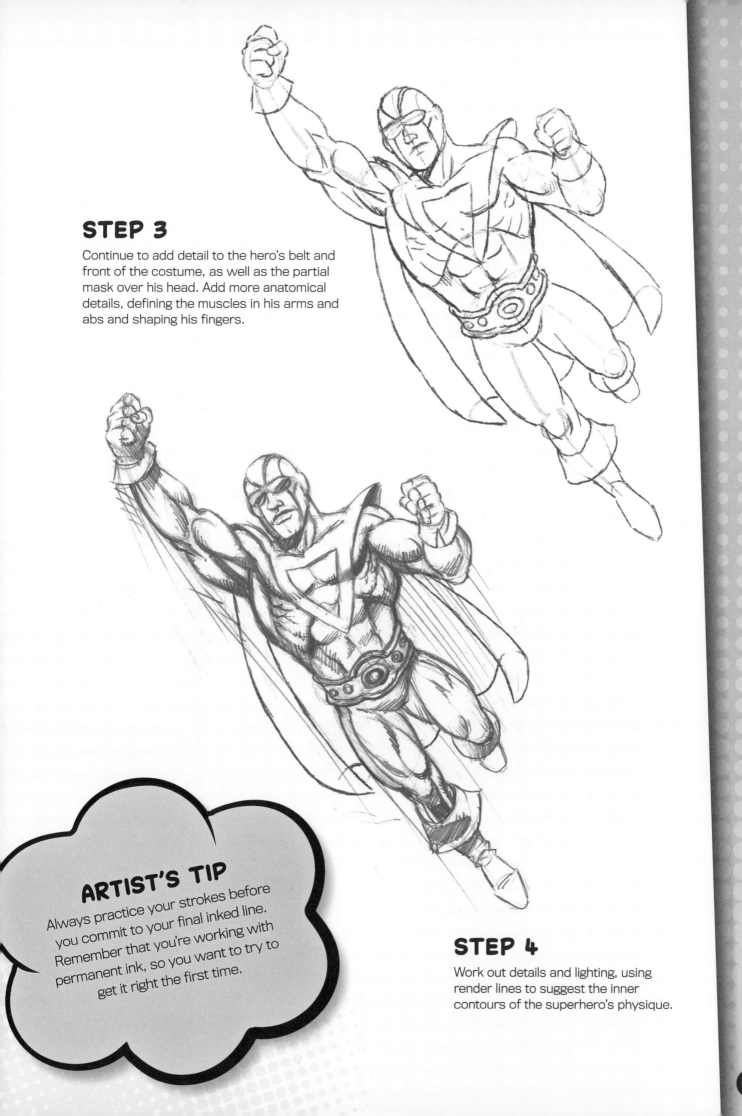

STEP 3

Continue to add detail to the hero's belt and front of the costume, as well as the partial mask over his head. Add more anatomical details, defining the muscles in his arms and abs and shaping his fingers.

ARTIST'S TIP

Always practice your strokes before you commit to your final inked line. Remember that you're working with permanent ink, so you want to try to get it right the first time.

STEP 4

Work out details and lighting, using render lines to suggest the inner contours of the superhero's physique.

STEP 5

Use india ink and a medium pointed round brush to start inking the outline of the figure. Keep your brush clean and twirl it constantly to retain a nice point. For finer details or areas where you need more control, use a quill dip pen or a very fine waterproof marker with a soft nib. The light source is to the upper right, so draw the lines on the lower left a little heavier to suggest shadow.

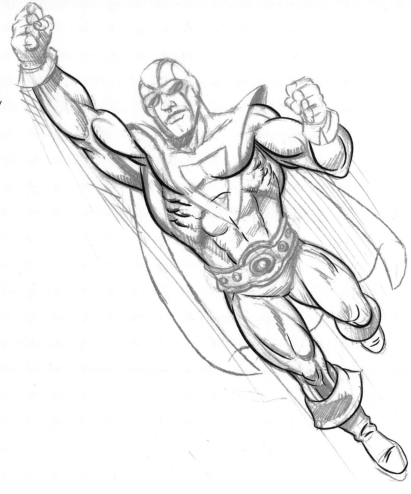

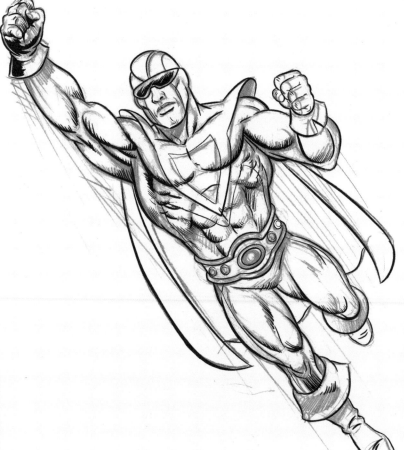

STEP 6

Time to focus on the interior contours and details. Use feathered lines to start lining muscles and shadows. Note that the rendering is only used to clarify the drawing and make the transitions of form distinct. Feathering is difficult to master, so make plenty of practice strokes before making your final marks.

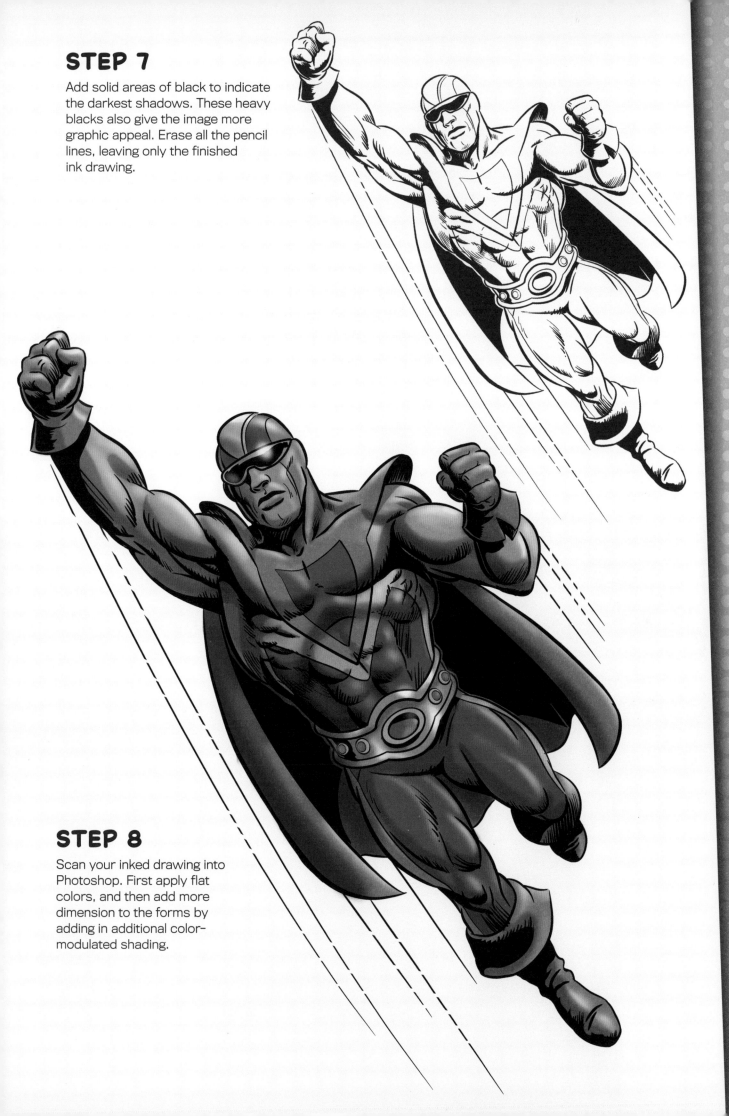

STEP 7

Add solid areas of black to indicate the darkest shadows. These heavy blacks also give the image more graphic appeal. Erase all the pencil lines, leaving only the finished ink drawing.

STEP 8

Scan your inked drawing into Photoshop. First apply flat colors, and then add more dimension to the forms by adding in additional color-modulated shading.

Ms. Mega

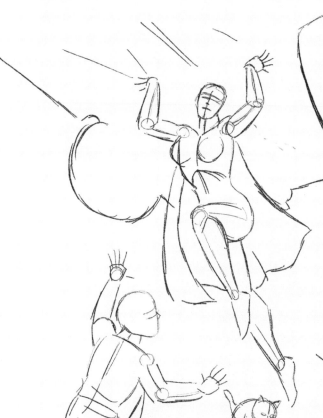

STEP 1

Now that you have many projects under your proverbial utility belt, start drawing this action sketch using more complete masses and cylinder shapes.

STEP 2

Start adding clothing and capes to the characters. Use a reference photo to add some details to the underside of the car. Using a light box to trace over your reference is a useful "cheat" to capture mechanical and background elements quickly and accurately.

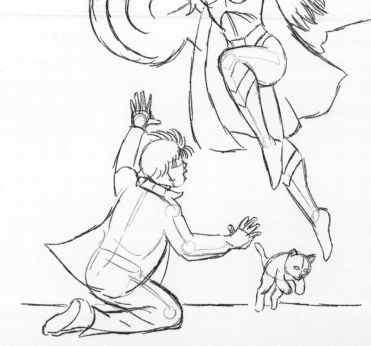

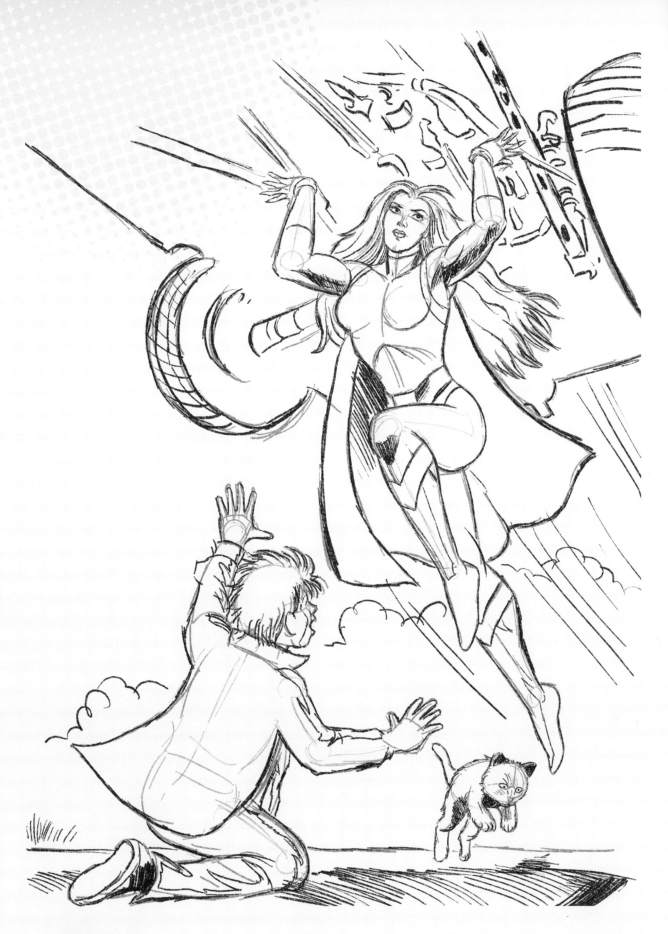

STEP 3

Erase the more sketchy lines while you refine the drawing. At this point, capture the expressions of the characters in the scene and rough in most of the costume and clothing detail. Trace in a few more details on the car.

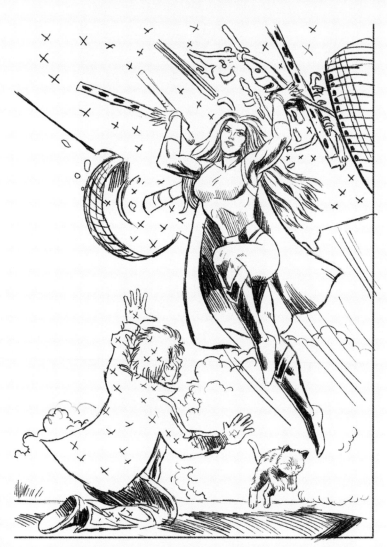

STEP 4

Add some lines and hatch marks to indicate shading. Leave the details of the car rough, as you can trace them in ink directly from the reference. Add little "x" marks to remind you of where to add solid blacks.

STEP 5

Begin to ink in Ms. Mega, using a brush to easily vary the line weight and add rendering lines. Her hair is especially fun to ink. Use a very thin, varied line to give the impression of flowing locks. Don't illustrate every strand, but add enough detail to her hair to make it interesting. Use a quill pen and an artist pen to render her face because the detail is very fine and a little tricky for brushwork. Spot in strong black shadows on her boots.

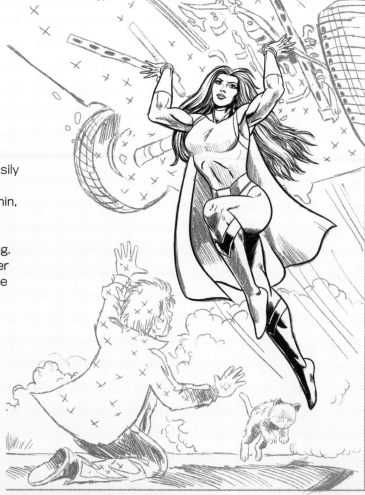

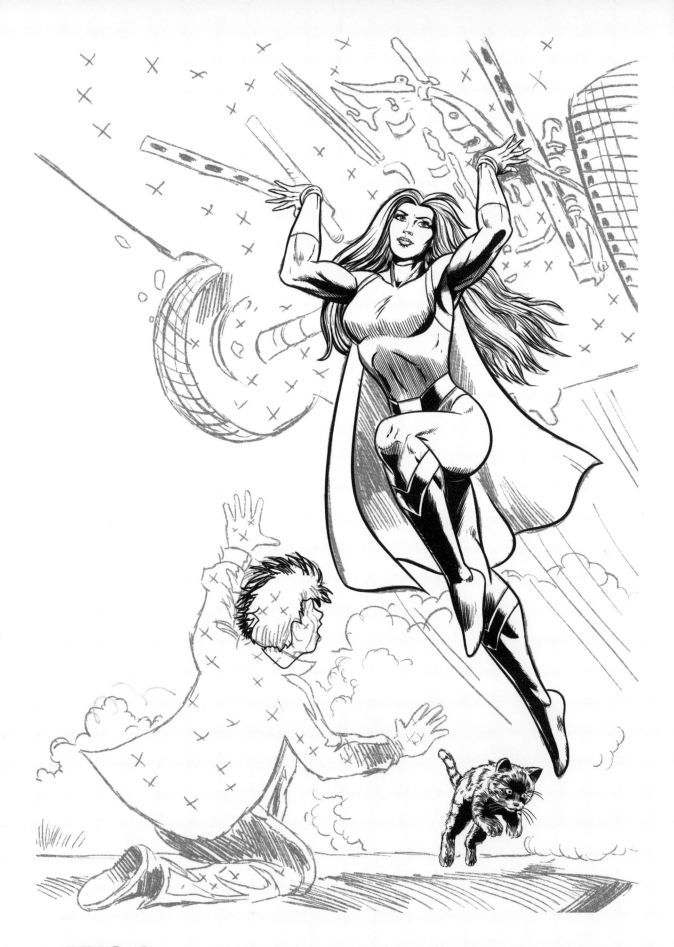

STEP 6

Use a slightly dry #2 brush with a fine point and make short, rapid brushstrokes to evenly hatch around her torso. Make a lot of practice strokes first to get the rhythm down. Then use the same technique on the undersides of her arms. This kind of hatch work suggests softer shadows with a lot of reflected light. Spot dense black shadows on the very underside of her uplifted arms, which detail the musculature in her arms as well as make her figure look bold and powerful.

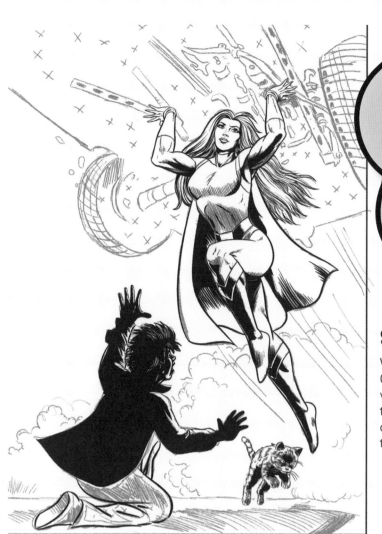

STEP 7

With Ms. Mega completed, move on to the boy. Outline the areas of deep shadow and fill them with solid black in his upper body and outline the lower body. Use white paint to bring out the details of the boy's hair and face; this is easier than trying to ink around small areas.

STEP 8

Fill in the shadows of the boy's legs and quickly ink in the road surface and the billowing cloud of dust left by the car. Use a brush in a very loose, free motion.

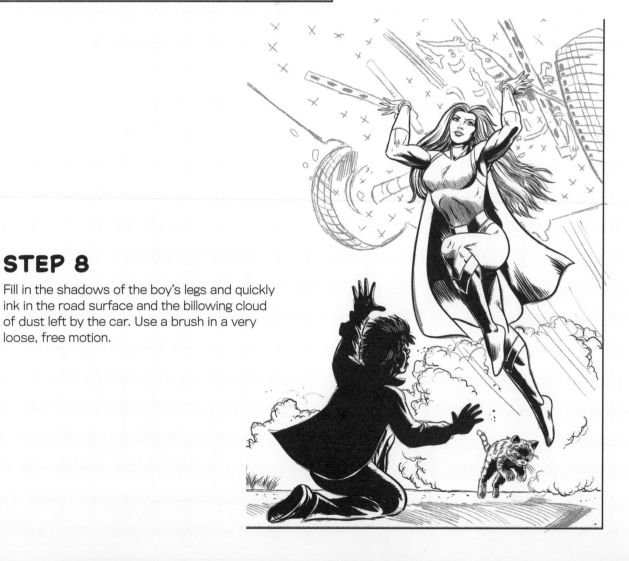

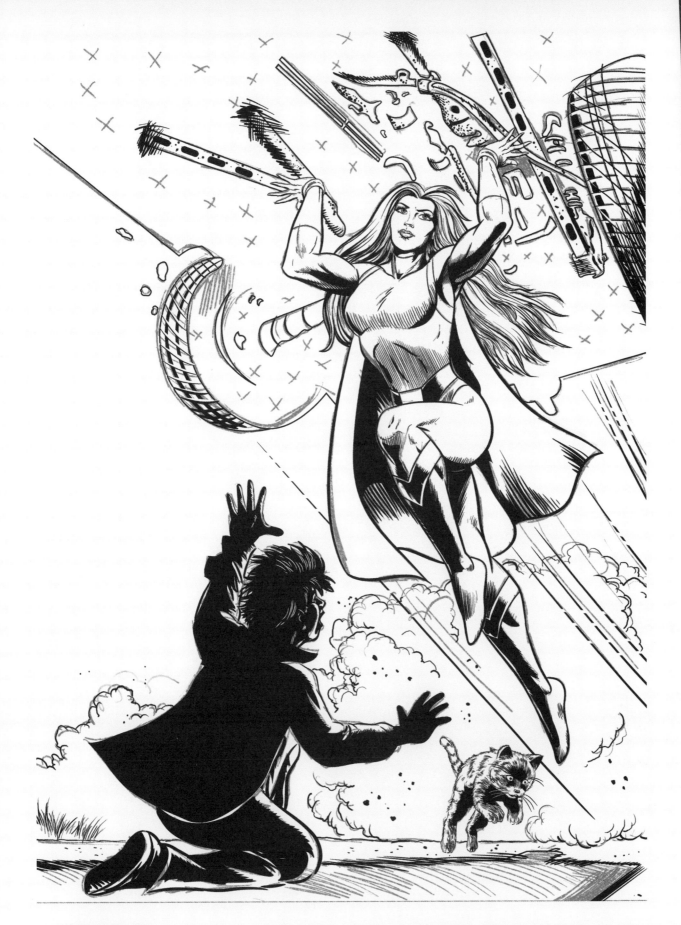

STEP 9

You want to suggest the complex workings of the car's undercarriage without drawing something too complicated. The trick to doing so is to only render a few details and let deep black shadows and a few mechanical highlights create the illusion. Using an art pen, begin outlining some of the more "automotive-looking" details: axles, springs, some struts, and brake lines.

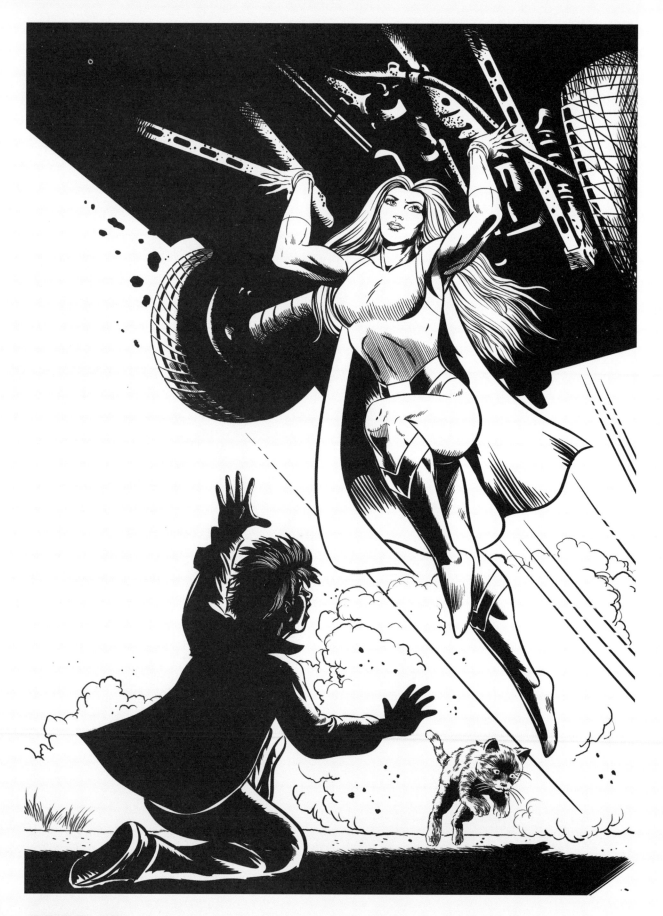

STEP 10

Fill in the large area of the car's undercarriage with black ink and erase the pencil lines. Note how the small amount of detail drawn In the previous step really gives the impression of complex machinery. Add a few more hatch lines around the wheels and other places to complete the effect.

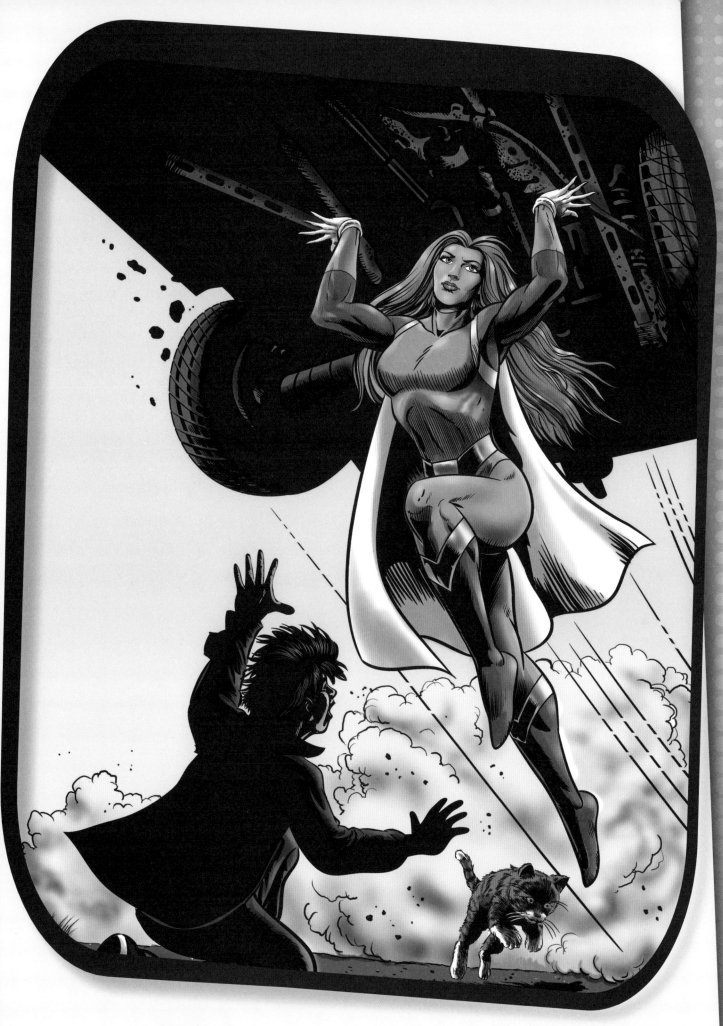

STEP 11

Use markers or scan the finished ink into Photoshop and add color.

Thorn

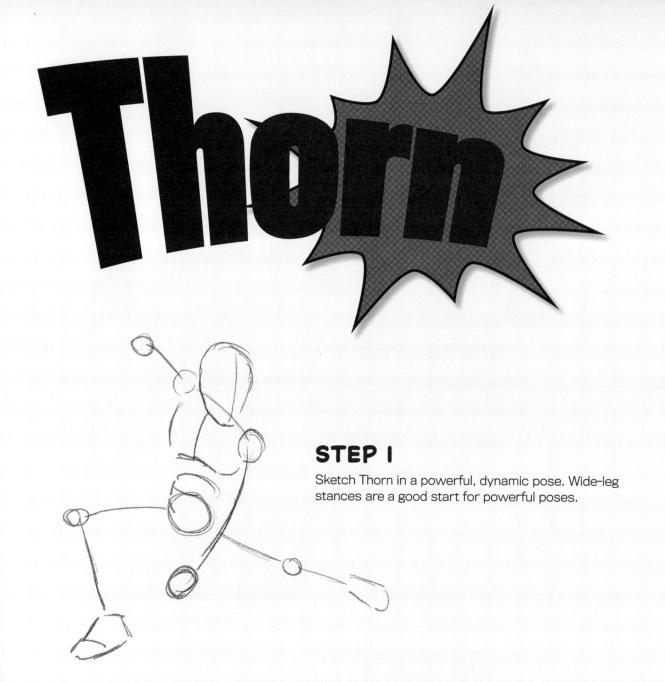

STEP 1

Sketch Thorn in a powerful, dynamic pose. Wide-leg stances are a good start for powerful poses.

STEP 2

After the gestural pose, start to sketch out some of the mass and volume of Thorn's figure to add depth and volume to his body, arms, and legs.

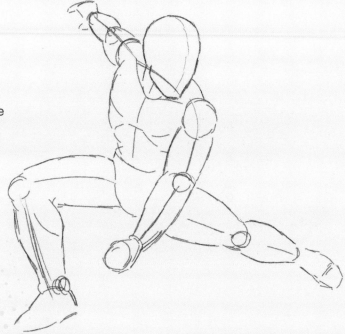

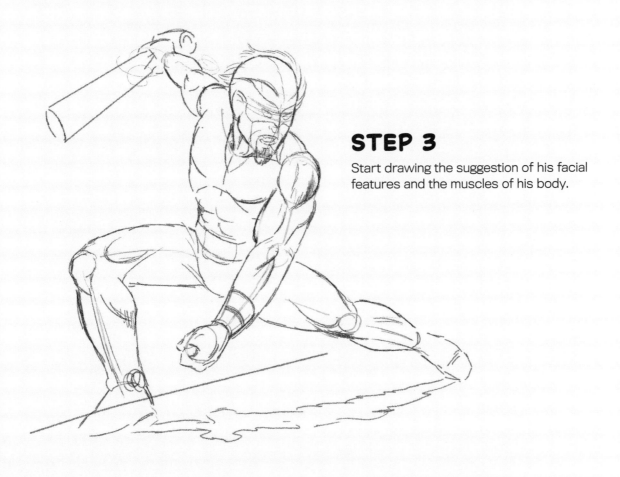

STEP 3

Start drawing the suggestion of his facial features and the muscles of his body.

STEP 4

Your sketch should be nearly complete, showing all of Thorn's muscles and suggestions of shadows. Add a rough sketch of the tank he is standing on.

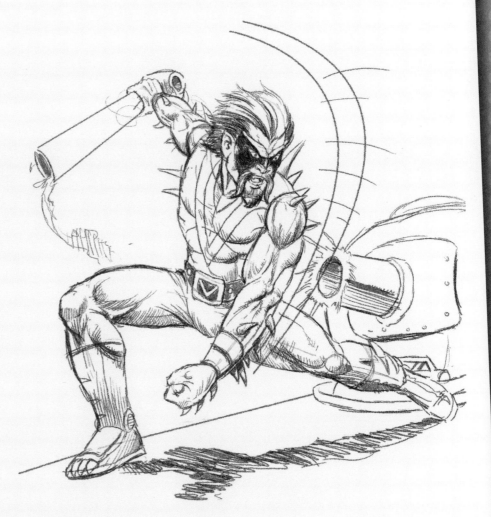

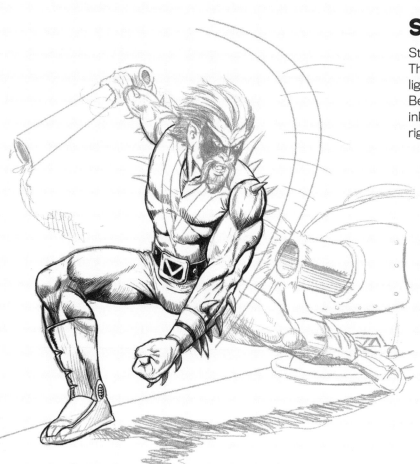

STEP 5

Start inking the pencil sketch. Outline Thorn's body with a quill pen and make the lighter, feathered shadow lines with a brush. Be careful not to overload your brush with ink when hatching or feathering. Outline his right boot, which will be a very dense black.

STEP 6

Add more details to Thorn's body, using a lot of crosshatching and feathering with a brush. The challenge is to render Thorn's powerful muscles but also give his body a sense of mass, using very strong black shadows. Maintain a number of white areas inside the body so the figure doesn't look overdone.

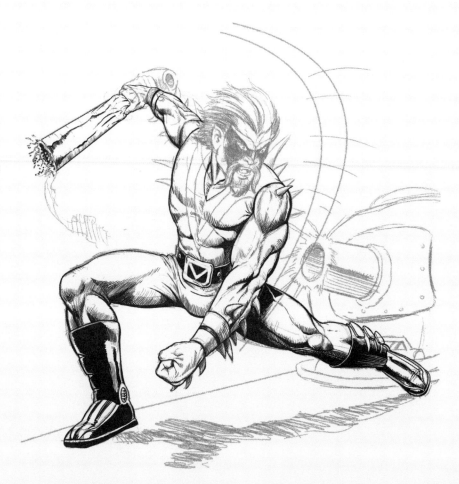

STEP 7

Next ink Thorn's face and expression, which really makes the figure come together. This mutant is a bit of a raging berserker, so give him an unhappy expression. Complete the thorns protruding from his back—having this guy over as a house guest could really do a number on your furniture!

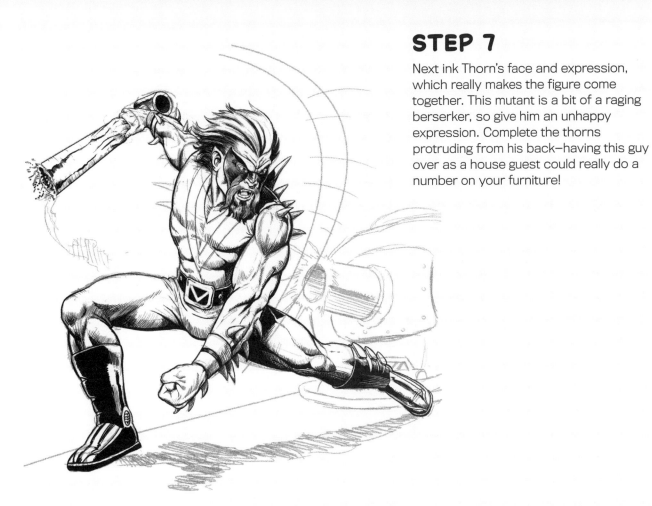

STEP 8

Ink the tank turret and deck that Thorn is standing on. Although these are background elements, they are equally important to the drawing. Pay careful attention to how Thorn's shadow falls on the tank. Use crosshatching to suggest a semi-diffused shadow. Use an artist pen to add speed lines to increase the sense of action.

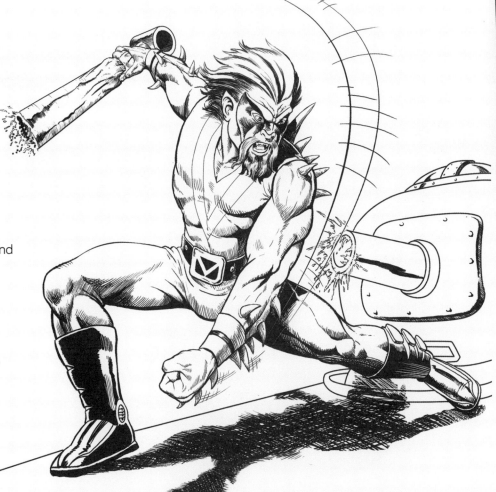

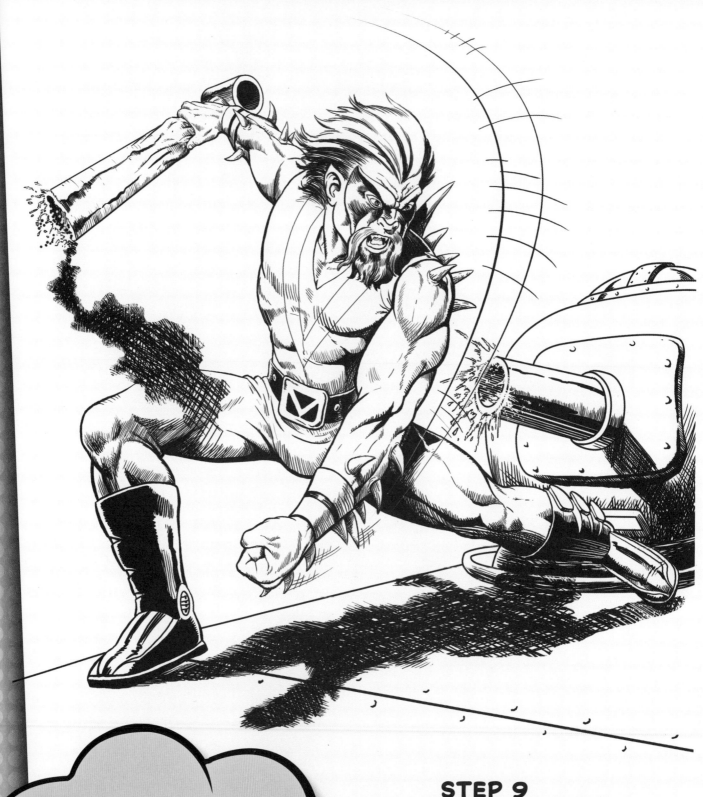

ARTIST'S TIP

Speed lines can be tricky! Use flexible guides, especially when they span as much distance as these do. Use artist pens with a little flexibility in the nib, which can render a line that gently runs from thick to thin for a more dynamic line.

STEP 9

Add crosshatched shadows to the tank, which define the rounder form of the turret. The rendering on the tank helps to fully integrate the tank into the drawing. Because Thorn's barbs cut at the molecular level and generate a lot of heat, render sparks on both ends of the gun barrel. Add a stream of smoke trailing from the broken barrel to complete the effect.

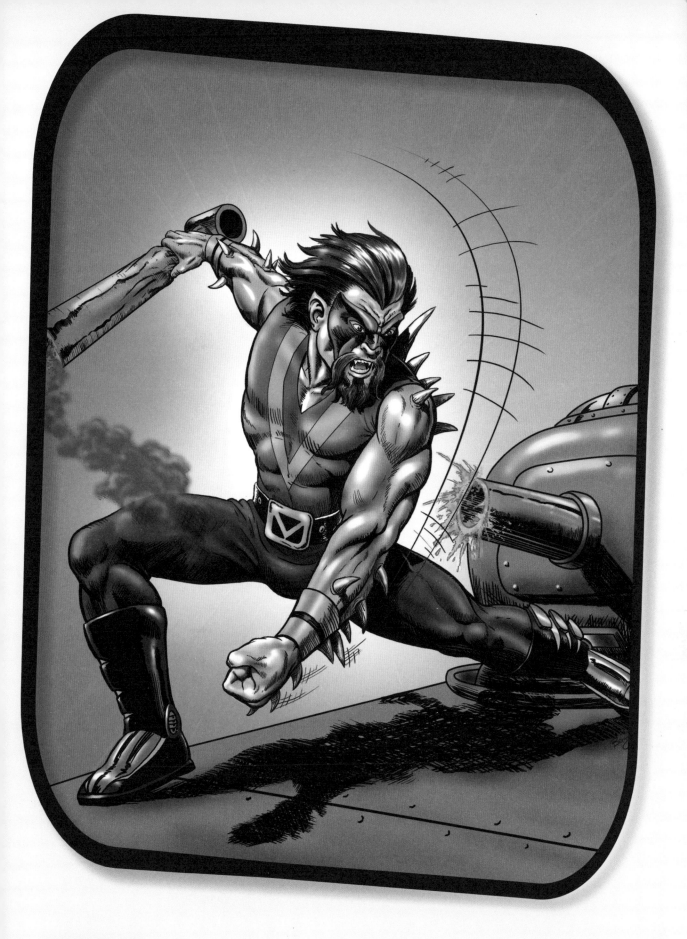

STEP 10

Scan the inked drawing into Photoshop to add color. Convert the black ink lines around the heated ends of the severed gun barrel to glowing red lines. Add a subtle orange glow to the objects closest to the glowing metal of the gun barrels. Then render the smoke to give it a nice, billowing feel. Finally no comic "splash" page would be complete without a nice burst around the center of action. Bursts like this are another convention that can impart action, speed, and direction to your comics.

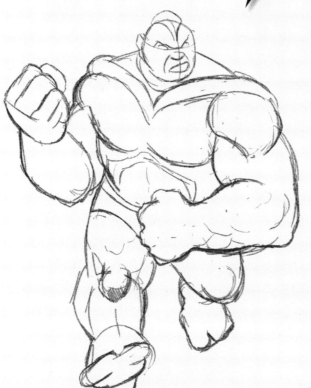

STEP 1

Start by sketching out a rough version of the figure, using full shapes for his arm and his legs. Indicate some of the largest muscle groups and the structure of his armor-plated shoulders. Rough in the details of his head and erase unnecessary sketch lines.

STEP 2

Sketch in his blocky skin texture. Block in the dark, solid shadow shapes, which help establish the mass of the creature.

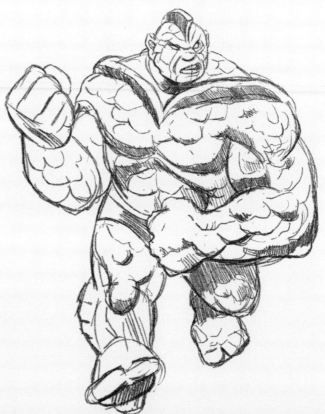

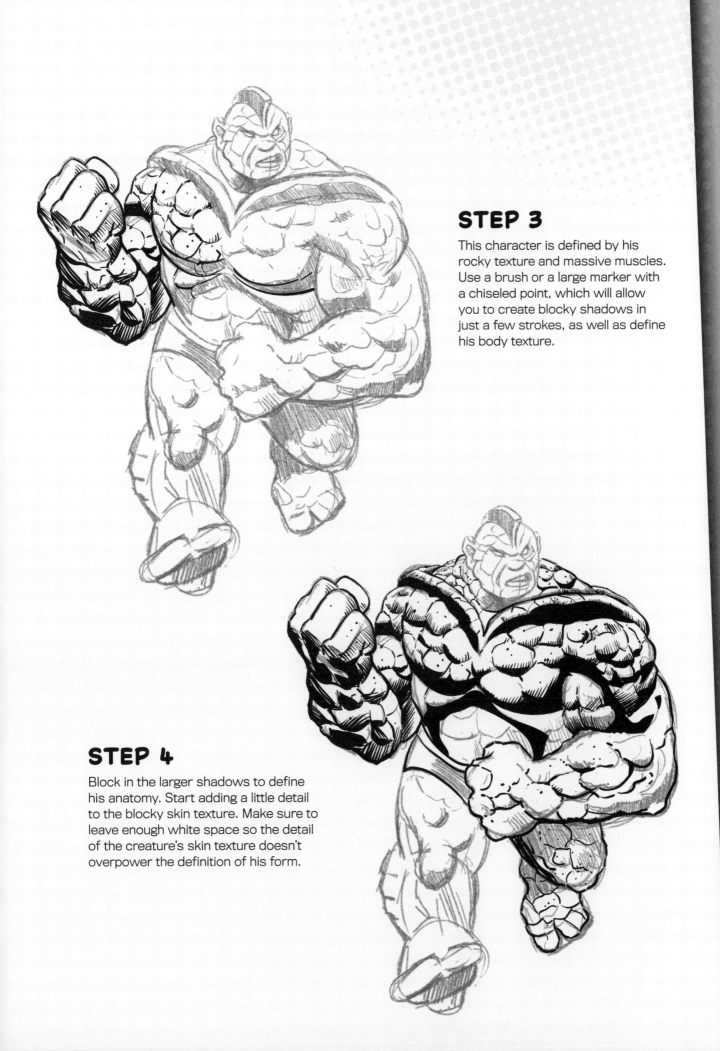

STEP 3

This character is defined by his rocky texture and massive muscles. Use a brush or a large marker with a chiseled point, which will allow you to create blocky shadows in just a few strokes, as well as define his body texture.

STEP 4

Block in the larger shadows to define his anatomy. Start adding a little detail to the blocky skin texture. Make sure to leave enough white space so the detail of the creature's skin texture doesn't overpower the definition of his form.

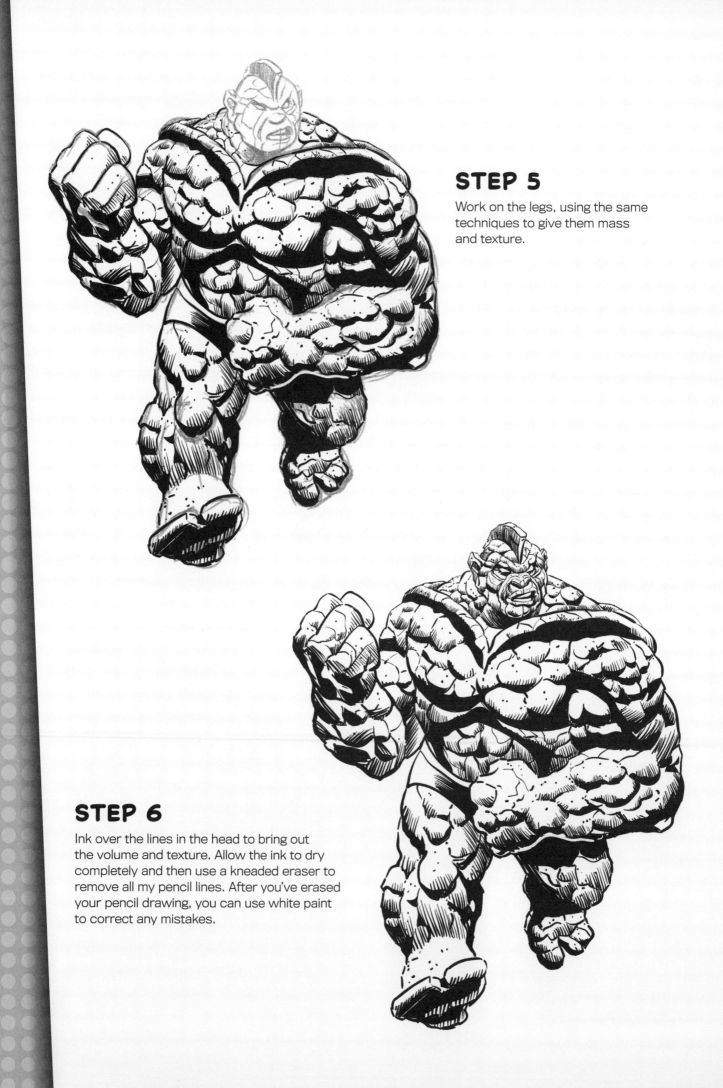

STEP 5

Work on the legs, using the same techniques to give them mass and texture.

STEP 6

Ink over the lines in the head to bring out the volume and texture. Allow the ink to dry completely and then use a kneaded eraser to remove all my pencil lines. After you've erased your pencil drawing, you can use white paint to correct any mistakes.

STEP 7

Color in the entire creature with blue. Then overlay a darker blue on the shadows to help further define his skin texture and form. Add highlights to the upper edges of the bumps on his skin. Now this creature is ready to clobber some bad guys!

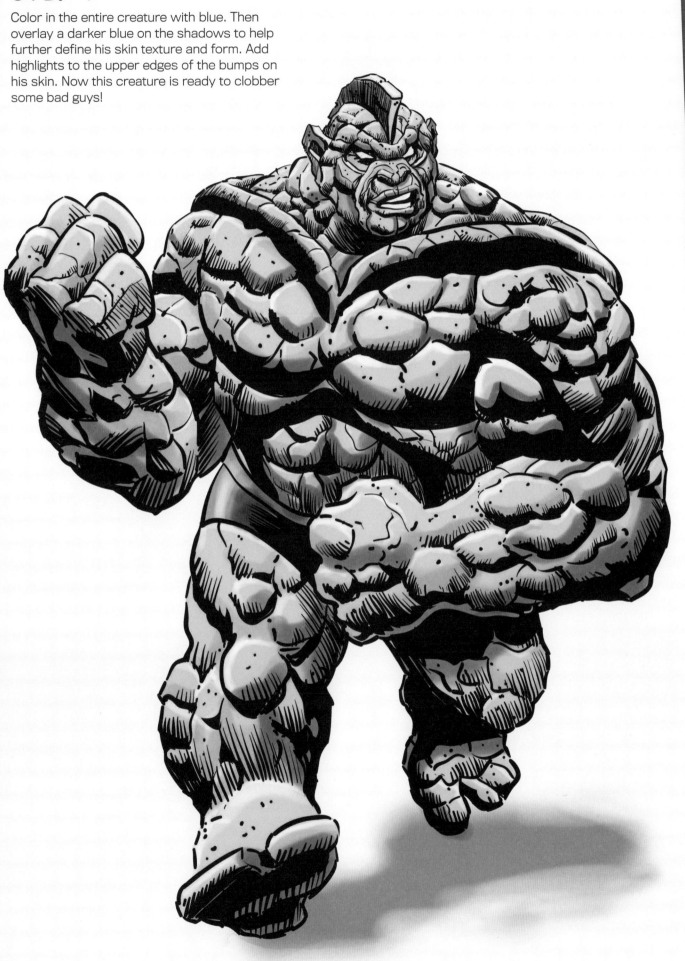

Lady Electric

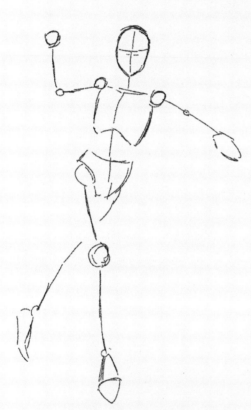

STEP 1

As always, begin with a rough action sketch. Lady Electric is on the attack, so draw her in mid-stride as she shoots a bolt of energy through her fingers.

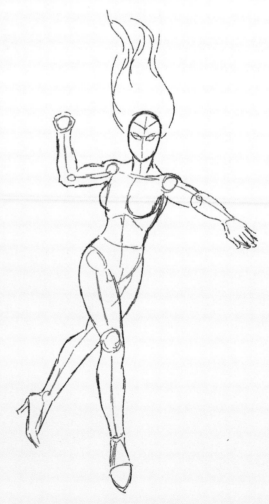

STEP 2

Next begin to embellish, adding detail and refining her anatomy and pose. Because she is electrified, her hair stands straight up! Draw some lines suggesting the look of her mask and some details on her costume.

STEP 3

Erase most of the sketch lines and tighten some of the lines that describe the villainess. Add in details of her gloves, boots, and costume. Start to draw in her muscles, and then draw in a lightening bolt motif throughout her costume.

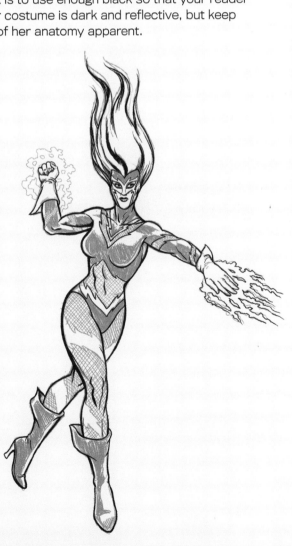

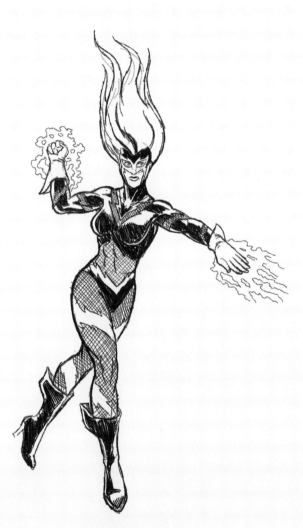

STEP 4

Finish up the pencil sketch by adding shading and other details. Shade areas of full black to suggest shininess. The trick is to use enough black so that your reader sees her costume is dark and reflective, but keep enough of her anatomy apparent.

STEP 5

Once satisfied with the pencil drawing, ink the longer lines of her body with a #2 brush loaded brush with a good amount of ink so the line flows well. The thick line on the outside of her right leg requires a couple of strokes.

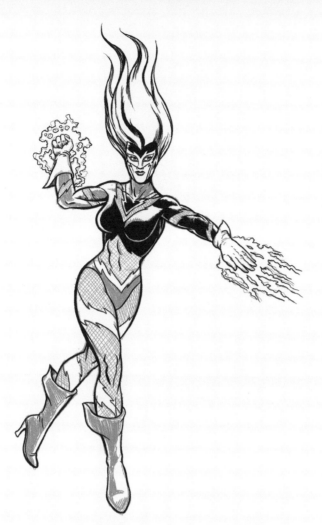

STEP 6

Outline the black areas on the top of her costume with a pen first to give them a crisp edge and then fill them in. You may wish to work differently, laying in your dark areas directly with your brush or a large marker for a more spontaneous look. Feel free to experiment and invent your own style!

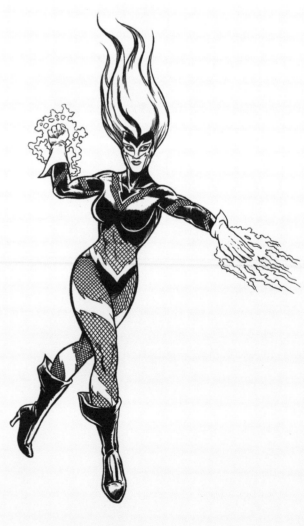

STEP 7

Finish the outline and solid black areas on the bottom of the costume and her boots. Next crosshatch areas of her costume using an artist pen and a "dead" line. Use a steady line that doesn't have that thick-and-thin quality.

ARTIST'S TIP

You'll be amazed how practicing strokes can allow you to execute them successfully on your final drawing. The more you ink, the better you'll get!

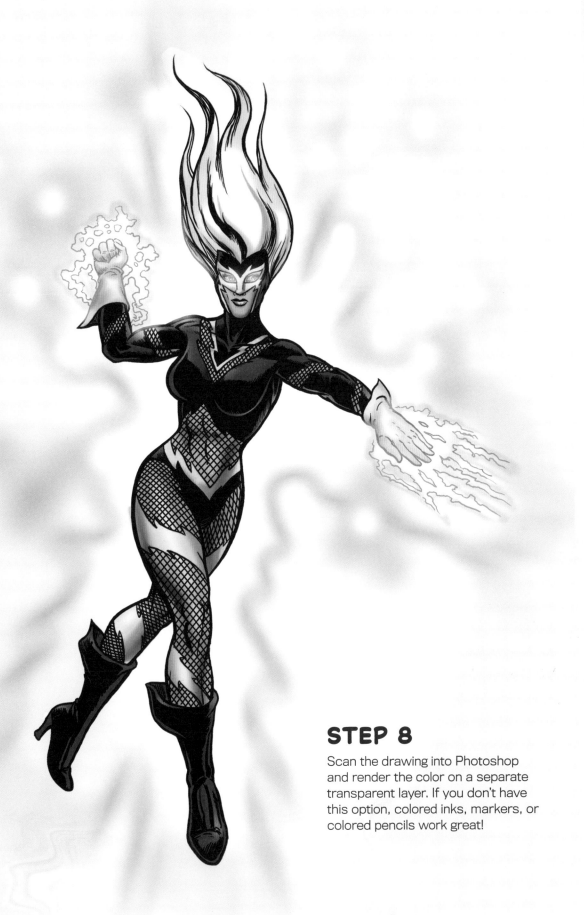

STEP 8

Scan the drawing into Photoshop and render the color on a separate transparent layer. If you don't have this option, colored inks, markers, or colored pencils work great!

The Shark & The Tadpole

STEP 1

Starting your superhero team project with simple stick figures is a good way to capture action and body proportions quickly. Lightly sketch the scene with a soft #2 pencil. Work freely and lightly—the drawing will take on more detail in each step.

ARTIST'S TIP

If you really love your pencil drawing, photocopy it before inking. It can be fun to compare your pencil drawing to your final ink drawing!

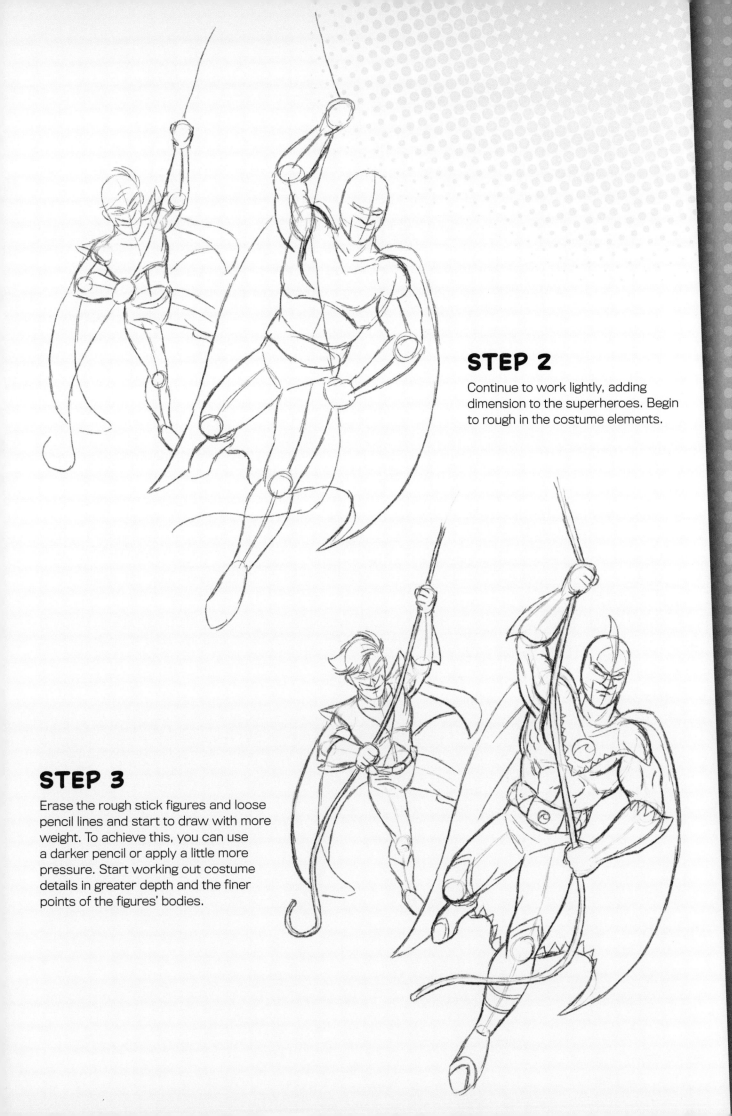

STEP 2

Continue to work lightly, adding dimension to the superheroes. Begin to rough in the costume elements.

STEP 3

Erase the rough stick figures and loose pencil lines and start to draw with more weight. To achieve this, you can use a darker pencil or apply a little more pressure. Start working out costume details in greater depth and the finer points of the figures' bodies.

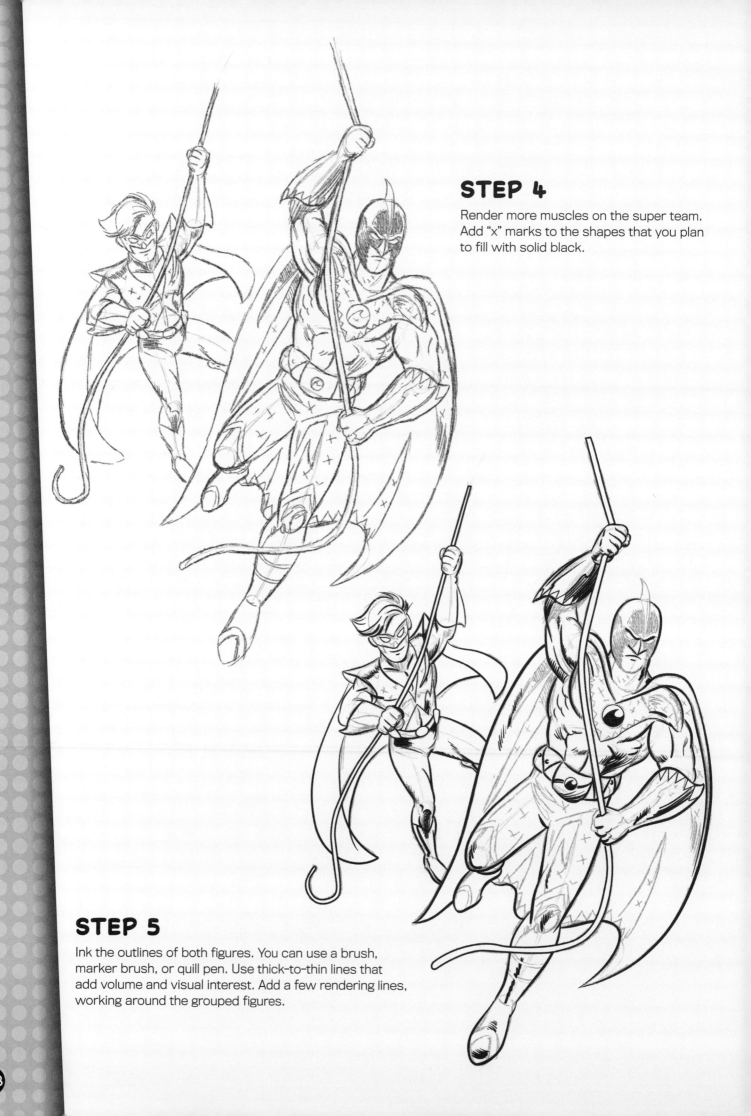

STEP 4

Render more muscles on the super team. Add "x" marks to the shapes that you plan to fill with solid black.

STEP 5

Ink the outlines of both figures. You can use a brush, marker brush, or quill pen. Use thick-to-thin lines that add volume and visual interest. Add a few rendering lines, working around the grouped figures.

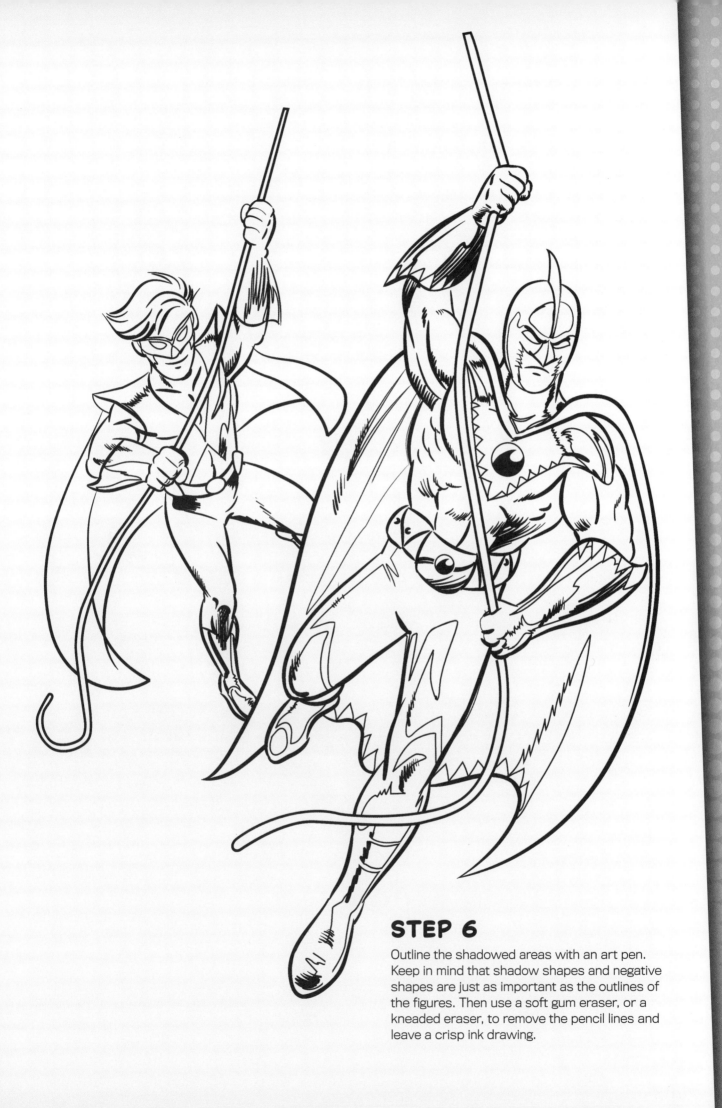

STEP 6

Outline the shadowed areas with an art pen. Keep in mind that shadow shapes and negative shapes are just as important as the outlines of the figures. Then use a soft gum eraser, or a kneaded eraser, to remove the pencil lines and leave a crisp ink drawing.

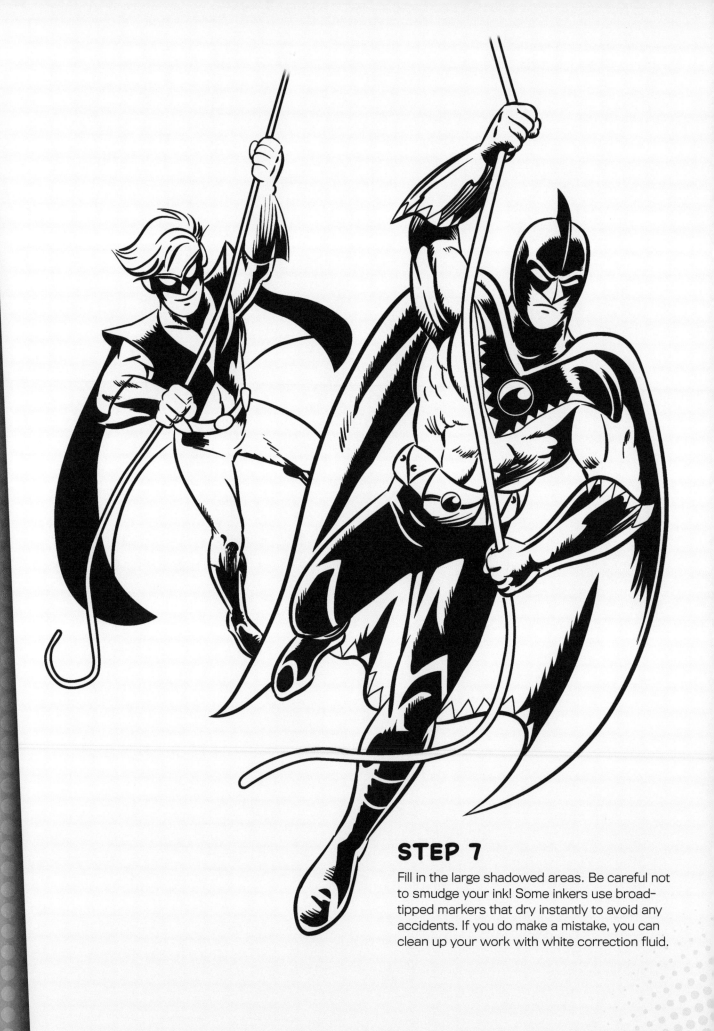

STEP 7

Fill in the large shadowed areas. Be careful not to smudge your ink! Some inkers use broad-tipped markers that dry instantly to avoid any accidents. If you do make a mistake, you can clean up your work with white correction fluid.

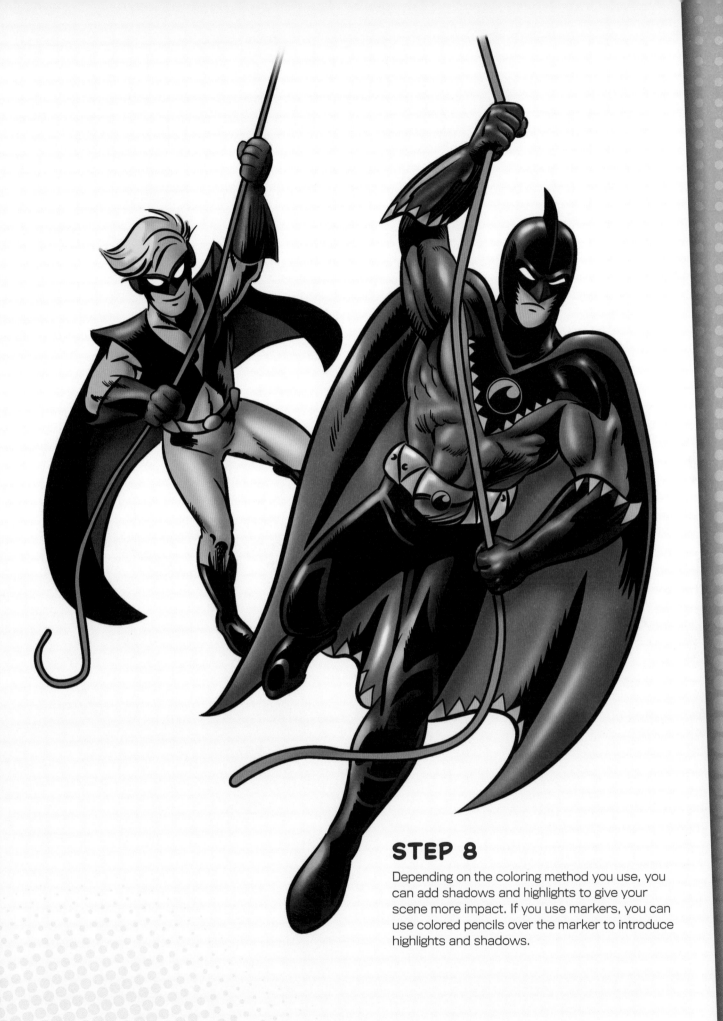

STEP 8

Depending on the coloring method you use, you can add shadows and highlights to give your scene more impact. If you use markers, you can use colored pencils over the marker to introduce highlights and shadows.

Adding Speech

Lettering is often an afterthought in comic book art, but the speech balloons and sound effects are often as important as the drawings themselves. Let's take a quick look at how to add speech and sound bubbles to your scenes.

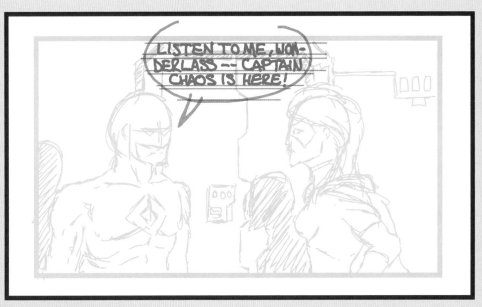

Draw the rough balloon and guides in pencil, then add words. Don't be afraid to erase and rewrite until you have a block of text that looks attractive. If lines of text don't comfortably fit the space, erase and try again. Avoid breaking words with hyphens and don't squash words to make them fit under any circumstance!

When you are happy with how the text fits in the balloon, neatly render the letters in black ink. Use an ellipse template to draw a perfect balloon, leaving a small gap for the balloon's tail, which you can draw by hand. When all the lettering is complete on a page, the art is ready for inking.

Speech or narration can be contained in different-shaped balloons depending on the nature of the text. These balloon types are: speech, double outline, burst, radio, thought, whisper, and weak. Can you tell which of these balloons is an example of each of these types? (See answers at the bottom of the page.)

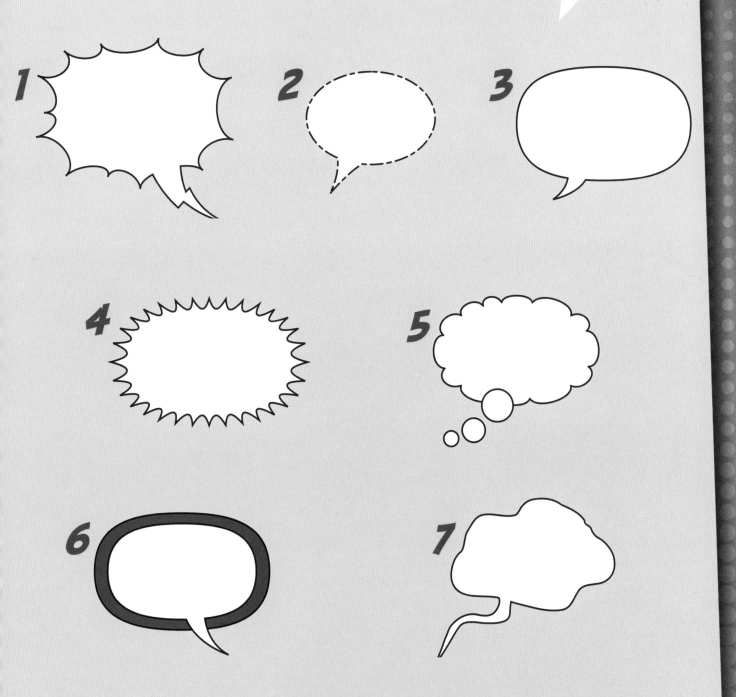

ANSWERS: 1 – Burst; 2 – Whisper; 3 – Speech; 4 – Radio; 5 – Thought; 6 – Double Outline; 7 – Weak.

BURST BALLOONS

Burst balloons are used for shouting, screaming, alarm, or any kind of speech that may require extra emphasis. You can combine them with larger text, a bolder font, or both!

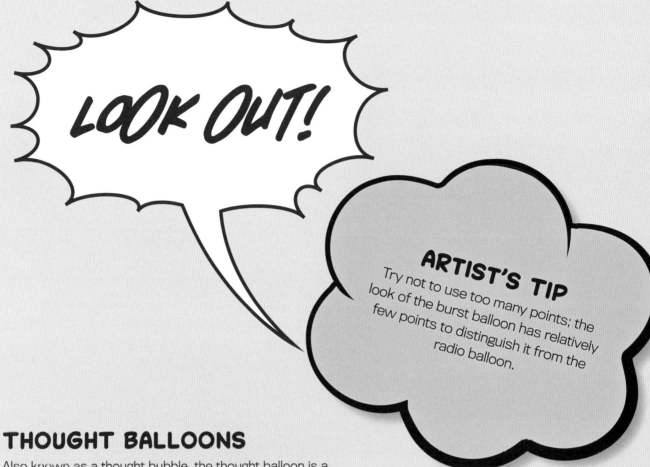

LOOK OUT!

ARTIST'S TIP
Try not to use too many points; the look of the burst balloon has relatively few points to distinguish it from the radio balloon.

THOUGHT BALLOONS

Also known as a thought bubble, the thought balloon is a useful method of giving the reader quick insight into what a character is thinking or feeling in a way that narrative captions may sometimes fail to do. Note that text inside thought balloons is usually italicized.

ARTIST'S TIP
Thought balloons are almost the same as burst balloons. Draw a set of small circles that get smaller the closer they are to the character.

WHAT ON EARTH IS THAT?!

WHISPER BALLOONS

Whisper balloons are somewhat out of fashion today. Many letterers prefer the use of a lowercase lettering font to show that a character is whispering, but the use of a traditional whisper balloon is still perfectly valid.

A TRADITIONAL WHISPER BALLOON HAS ITALIC TEXT IN A BALLOON WITH A DASHED OUTLINE.

Although a normal balloon with lowercase text is more often preferred in recent years.

WEAK BALLOONS

Weak balloons differ from whisper balloons in that they are used to show dialogue that is quiet as the result of the speaker being ill, injured, or incapacitated.

WEAK BALLOON WITH NORMAL TAIL.

WEAK BALLOON WITH WISPY TAIL.

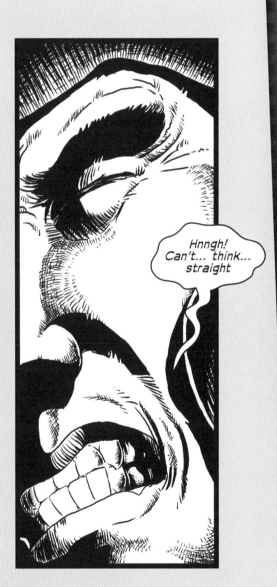

Hnngh! Can't... think... straight

LINKED BALLOONS

Linked balloons connect lines of dialogue from the same speaker that are not continuous. If a character has two consecutive lines of dialogue that are not directly related, the balloons should be linked rather than joined.

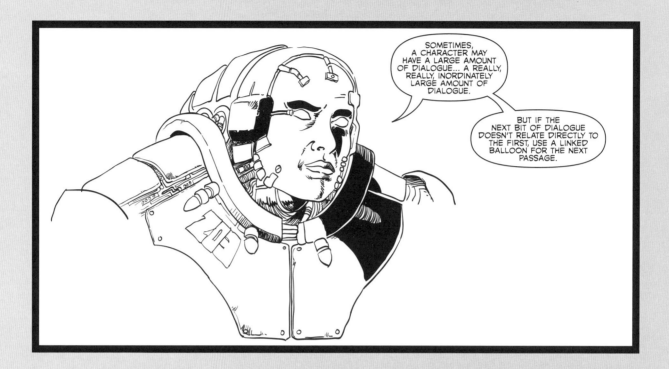

CAPTIONS

Captions are reserved for narrative text, either third person or first person. They can also be used for voice-over text—dialogue that is spoken aloud by a character not present in the current scene. In this case, the text also uses quotation marks.

Make sure other people can easily read your lettering at the size it will be printed.

Don't allow words to drift too closely to the edges of word balloons and center text in the balloon, even if you are aligning left or right.

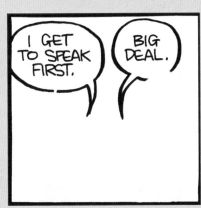

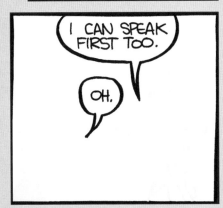

Ensure that the order of the balloons reflects the order in which the characters are speaking. People will read from left to right or top to bottom.

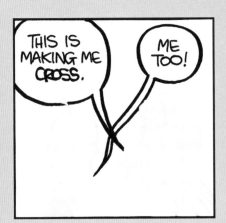

Don't cross word balloon tails. Redraw the panel, or rearrange the word balloons.

Avoid loose tails; they should point to the character who is speaking—ideally to their head.

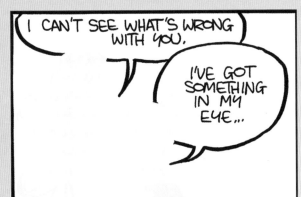

If you overlap your drawing into a word balloon, don't let the line cut into their eye level.

Sound Effects

There's good news and bad news regarding sound effects. The good news is that sound effects are simple to create. The bad news is that doing them well is tricky—so you need to practice, practice, and practice!

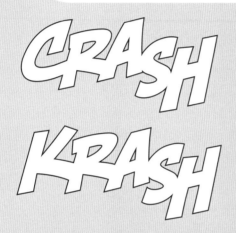

Sound effects are not simply onomatopoeia: words whose spelling and pronunciation are derived from the sound it describes, like "boom." The sound effect should visually complement the action or sound it is signifying. This is why "crack" or "crash" are often rendered on the comic page as "krak" or "krash."

Notice how the hard angles of the "K" visually represent the harsh, abrupt sound better than the gentler curves of the "C." Likewise, a repeated "O" visually complements the rolling sound of an explosion.

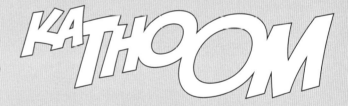

A letter like "E" creates lateral travel across the page for the reader's eye with its three horizontal strokes. As such, it's excellent in a sound effect for a skidding car.

The only punctuation you're likely to consider is an exclamation point. Just as with dialogue, upper- and lowercase denote different levels of loudness and dramatic effect. So, for example, a superhero punch is likely to be uppercase.

Arrange the letters so that they fit well on the art and look pleasing to you. Remember that larger is "louder" and smaller is "quieter," so you can create effects that trail off or look like they're increasing in volume.

Practice adding text to the speech bubbles below. Remember, the shape of the balloon should determine the nature of the caption.

IT'S YOUR TURN!

AAAAAAARGH AAAAAAARGH

You can experiment with outline thickness, but keep in mind that a heavy outline (stroke) might deliver some unattractive results.

Creating a Story Segment

Comics generally follow the same format. Full-sized boards measure 12"x16" with a live area of 10"x15". The live area is where all the art and copy goes. Comics haven't always followed this format and were often drawn on much larger boards. You don't have to use this format either; you can use any format you wish! But do work larger than your final printed size. This makes adding detail easier, and your drawing will look tighter when you print it in the reduced size.

THE PREMISE

PAGE 1: The mutant Thorn has been captured by the evil Dr. Genius, who has shackled him in his lab in mutant-proof restraints.

PAGE 2: Meanwhile, Ninja Warrior is stealthily skydiving into Dr. Genius's base, located on an island in the middle of a huge volcanic crater.

PAGE 3: We see Ninja Warrior subdue one of the island guards and notify Thorn through a hidden communicator that she is on the island. This entire breakout has been a setup to get our heroes behind the lines of Dr. Genius's hideout.

PAGE 4: Thorn uses his mutant ability to break out of his bonds, while Ninja Warrior fights her way through numerous guards to join him. The last panel is a cliffhanger, where Dr. Genius has donned his super-powerful exo-suit, ready to battle Thorn to the death.

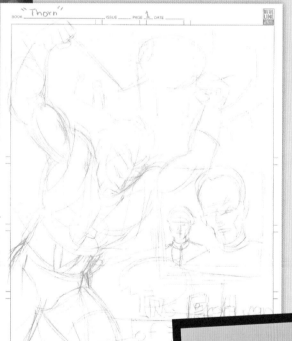

PAGE 1, STEP 1

Thorn has been captured by Dr. Genius, who has shackled him with mutant-proof restraints in his lab. Try working out the preliminary sketches right on the final boards in non-photo blue pencil. It doesn't pick up well on scanners and photocopiers, which allows you to work and rework your sketches on the final art boards without a lot of pencil dirt that would interfere with the final graphite drawings and subsequent inks. Initial layouts are rough. At this point, you're only trying to tell the story, establishing a nice flow of action and working out how best to break up the page in a visually interesting layout.

WHICH COMES FIRST—THE COPY OR THE ART?

By "copy," we mean the text. In the past, it was standard for a writer to provide a script much like a screenplay, and a penciller would draw sequential images to visually tell the story. Today the lines between writer and artist have blurred, and most comic creators often prefer to let the images tell the story with minimum text. Writers often work out the story line in small, rough thumbnail sketches. Sometimes the writer supplies an overview, like the premise above, to a penciller to work out the details and action. Then the writer and artist collaborate to fine-tune the action and how the story plays out. Upon completion of the art, the writer custom-fits the dialogue and captions to the art. There is no one way to work, and the only measure of a successful process is the finished comic. For this sequence, we're going to use the original method—working from the written premise.

PAGE 2, STEP 1

Meanwhile, Ninja Warrior is skydiving from an airplane into Dr. Genius's base, located on an island in the middle of a huge volcanic crater. The visual break-up is a little different here—for a more cinematic look, make the panels horizontal and break down Ninja Warrior's skydiving sequence to three simple panels.

PAGE 3, STEP 1

As promised, we see Ninja Warrior subdue one of the island guards. High-action sequences are much easier to draw than subtle sequences, and Ninja Warrior's approach to the guard may take some work to get right. Reverting these pages back to vertical panels allows quick cuts of perspective and the inset of Thorn getting Ninja Warrior's transmission.

PAGE 4, STEP 1

The action seems to play out best with several different-sized panels. There is an extreme close-up of Thorn as he starts to activate his mutant power and sprout thorns, which leads to an explosive splash panel as the shackles are thrown off. Then there is the small inset showing Ninja Warrior fighting her way to Thorn's side. Last is the final panorama, reestablishing the lab setting and the final battle between Thorn and the evil Dr. Genius.

THE NEXT STEPS

Now that the preliminary elements of the story sequence are in place, it's time to work out some of the finer details. Continue to work with non-photo blue pencil for now as you fine-tune the layouts and the poses of some of the characters.

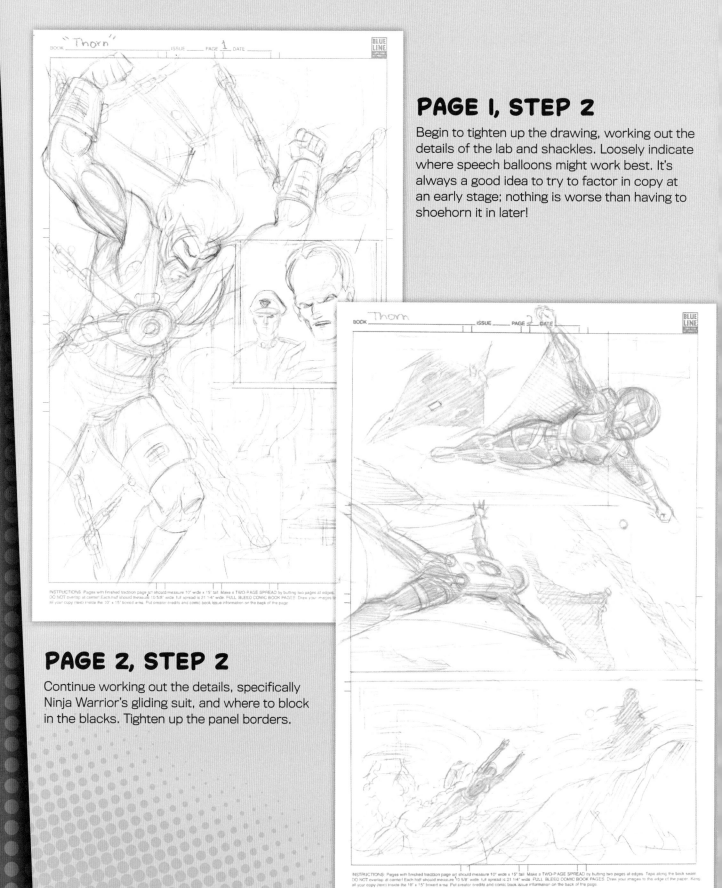

PAGE I, STEP 2

Begin to tighten up the drawing, working out the details of the lab and shackles. Loosely indicate where speech balloons might work best. It's always a good idea to try to factor in copy at an early stage; nothing is worse than having to shoehorn it in later!

PAGE 2, STEP 2

Continue working out the details, specifically Ninja Warrior's gliding suit, and where to block in the blacks. Tighten up the panel borders.

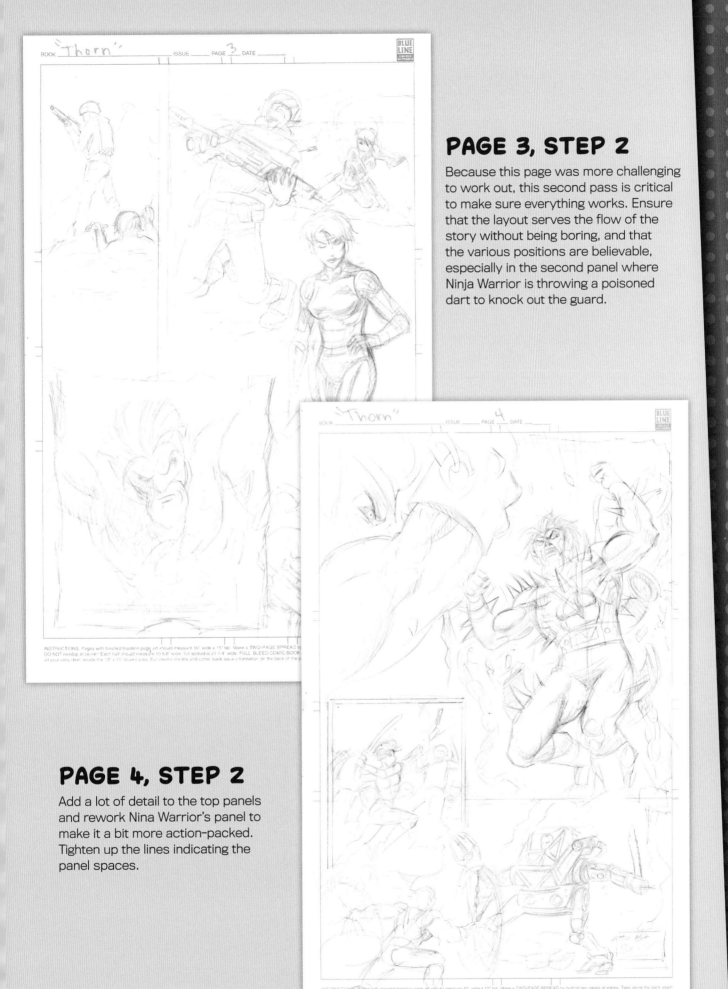

PAGE 3, STEP 2

Because this page was more challenging to work out, this second pass is critical to make sure everything works. Ensure that the layout serves the flow of the story without being boring, and that the various positions are believable, especially in the second panel where Ninja Warrior is throwing a poisoned dart to knock out the guard.

PAGE 4, STEP 2

Add a lot of detail to the top panels and rework Nina Warrior's panel to make it a bit more action-packed. Tighten up the lines indicating the panel spaces.

TIGHT PENCILS

The following images are the final graphite pencil drawings, which you can ink either traditionally, using inking tools (pen and brush), or digitally, using graphics software like Adobe Illustrator® or Photoshop. Create the captions in Adobe Illustrator, directly over scans of the pencil drawings.

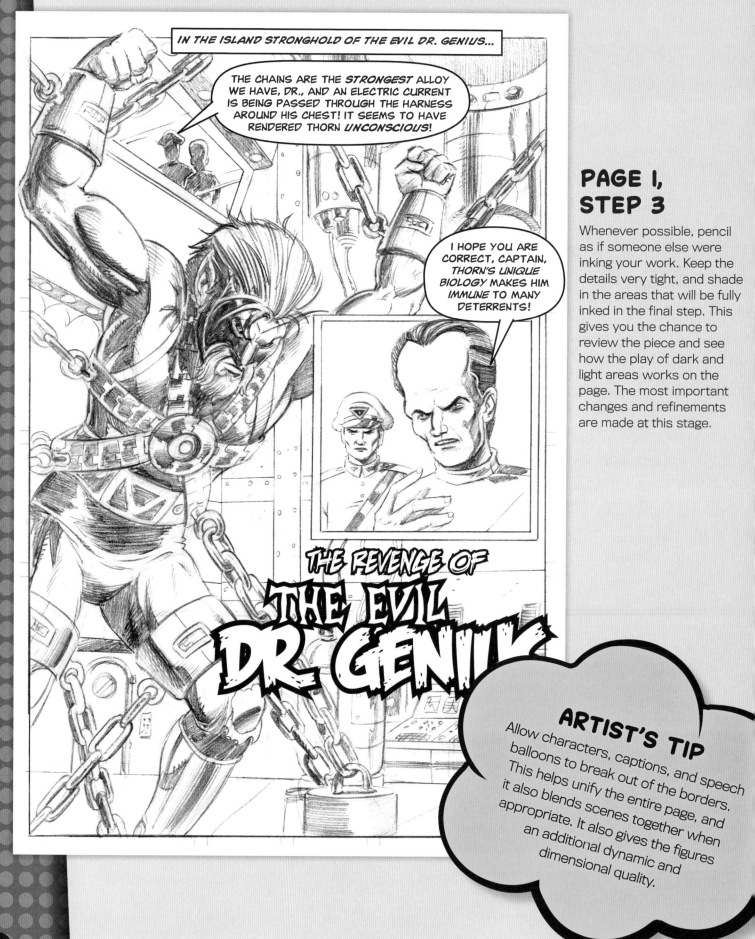

PAGE 1, STEP 3

Whenever possible, pencil as if someone else were inking your work. Keep the details very tight, and shade in the areas that will be fully inked in the final step. This gives you the chance to review the piece and see how the play of dark and light areas works on the page. The most important changes and refinements are made at this stage.

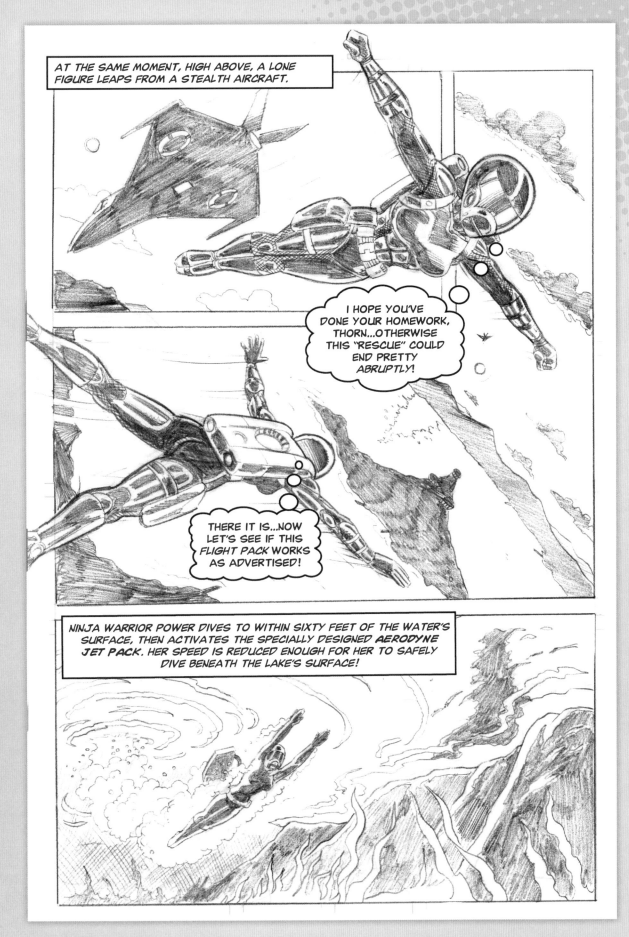

PAGE 2, STEP 3

The biggest change here is the deletion of Ninja Warrior's glider suit, which detracted from her overall look and covered some very important background elements. With the wings gone, she takes on more of a superhero look.

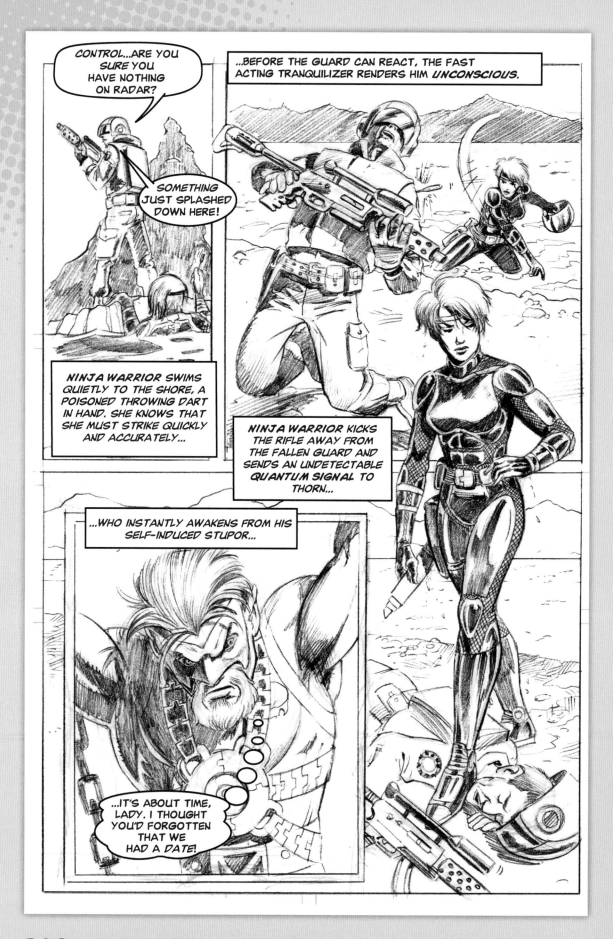

PAGE 3, STEP 3

In addition to shading in dark areas, determine the exact placement of the borders. The combination of light and dark, the placement of the captions and speech balloons, and the drawing of the borders transforms this page into a strong comic book scene.

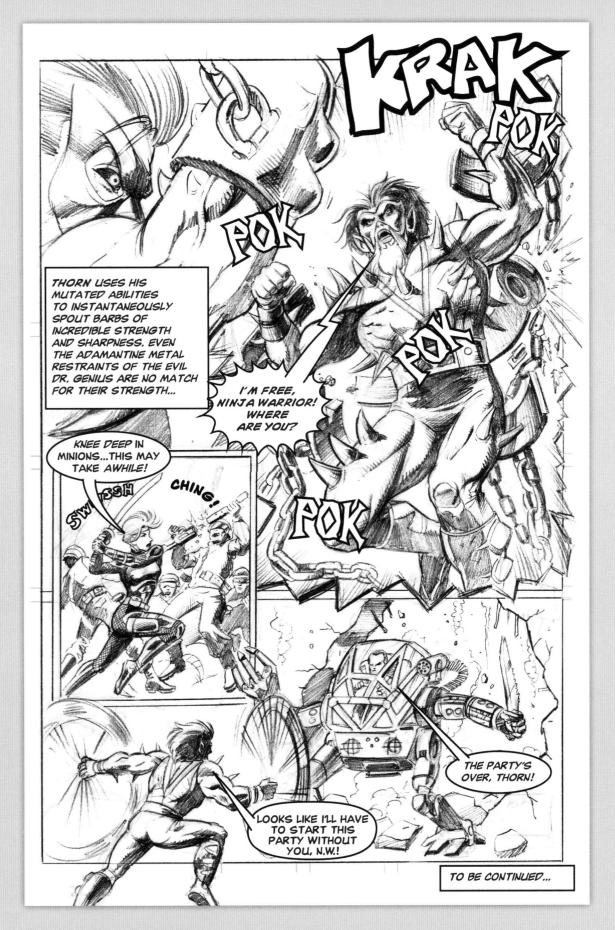

PAGE 4, STEP 3

When done correctly, sound elements can give your comic pages additional punch. But you need to consider carefully when and where you use them. Be inventive—coming up with new and interesting sound effects can be fun!

About the Artists

MAURY AASENG has always been excited about drawing and art. After graduating with a BFA in graphic design from the University of Minnesota–Duluth, Maury began an illustration career, and his work has spanned a variety of subject matter and illustration styles, including cartooning, medical illustration, natural sciences, patient education, and watercolor. An avid nature enthusiast, Maury lives in northern Minnesota with his wife and two children. Visit www.mauryillustrates.com and maurymedicalart.com.

BOB BERRY has been an artist, illustrator, and character and graphic designer for more than 15 years. While the mainstay of Bob Berry's work is for children's publishing and textbooks, Bob has also provided art and illustration for CDs, children's games, toy packaging, and more.

JIM CAMPBELL is a professional comic-book letterer, one-time writer (perhaps again in the future) and occasional artist–although his enthusiasm rather outstrips his actual ability. He knows more about print production than mortal man was meant to know and has scanned more images than you've had hot dinners. Unless you're 90 years old.

DANA MUISE is an artist working in San Francisco for the video game and TV cartoon industry. The only thing he likes better than space monsters is teaching people how to draw them. He enjoys drawing with his wife, Leigh, a talented artist, and daughter, Eva, his favorite little monster of all. Visit www.danamuise.net.

JOE OESTERLE is an award-winning writer and illustrator. He has worked as the Art Director of the Teenage Mutant Ninja Turtle apparel division and performed double-duty as Art Director and Senior Editor at National Lampoon. His work has appeared on television, radio, books, magazines, and websites. Joe is especially proud of the fact that a humorous animated short he wrote, directed, and voiced has been on display at the Smithsonian Institution since 2001. Visit www.joeoportfolio.com.